RITA BLITT

THE PASSIONATE GESTURE

RAM / BRANDEIS

The first edition of this book celebrates the opening of the Women's Studies Research Center at Brandeis University, Waltham, Massachusetts, and the accompanying exhibit, "Rita Blitt: The Passionate Gesture," Nov. 2000 - Feb. 2001.

Publication © RAM Publications, Brandeis University and Rita Blitt, Inc., 2000
Art Work © Rita Blitt, 2000

First Edition October 2000

Distributed in North America:
RAM Publications + Distribution
Bergamot Station 2525 Michigan Avenue, A-2
Santa Monica, CA 90404
Phone: 310-453-0043 Fax: 310-264-4888

Library of Congress Cataloging-in-Publication Data

Blitt, Rita.
 Rita Blitt : the passionate gesture.—1st ed.
 p. cm.
Published in conjunction with an exhibition held at the Women's Studies
Research Center at Brandeis University, Waltham, Mass., Nov. 2000-Feb. 2001.
Includes bibliographical references.
 ISBN 0-9630785-8-5
 1. Blitt, Rita—Exhibitions. I. Title: Passionate gesture.
II. Brandeis University. Women's Studies Research Center. III. Title.
N6537.B5635 A4 2000 709'.2—dc21 CIP 00-045759

Manufactured in the United States of America

Cover: Seeking Peace, 1998, acrylic on paper, 22" x 30"
Given to Olara Otunnu for the International Peace Academy,
New York, NY, which he founded in 1970.

CONTENTS

8 FOREWORD

11 DRAWINGS IN SPACE

47 COLOR EMBRACED

51 OVALS

61 MUSICAL SCULPTURE

67 LI PO POETRY

73 BLACK BOX

87 CHI

99 ICELAND

109 DANCING

123 CELEBRATION

133 THE JOURNEY

155 INTERVIEW

162 ACKNOWLEDGMENTS

163 LISTINGS

167 BIBLIOGRAPHY

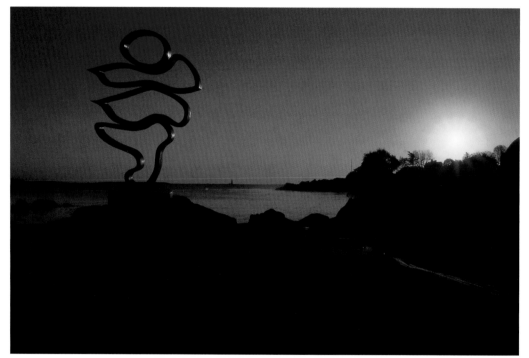

Joy in the leap of the sun.
Hurtling upward from the drowsy dark.
Alleluja the path sings.
Do you hear it?

Colette Inez, 1993

FOR

MY DEAR HUSBAND IRWIN

DAUGHTER CHELA

GRANDDAUGHTER DORIANNA

YEHUDA HANANI

International Soloist
Professor of Cello,
University of Cincinnati
College–Conservatory of Music

Rita Blitt's art and life are inseparable. Every gesture, in both, is borne on the wings of spontaneous responses unfettered by self-consciousness. Her constant search for the spirit and essence of reality is accompanied by a sense of wonder and mischief. The sculpture and drawings are by turn fluid and harmonious or rhythmic and staccato. In each instance they resonate with primal memories of collective symbols.

DAVID PARSONS

Dancer/Choreographer
Founder of The Parsons
Dance Company

In Rita's creations, I find movement caught in time. Her paintings and sculpture allow me to see elements of my dances, which normally pass too quickly. Once, in New York, we were in the studio creating *Step Into My Dream* to an incredible jazz score by Billy Taylor. Rita was there drawing — moving as fast as the dancers, sweating too, whipping out drawing after drawing — capturing motion on paper.

figs 2-9
Jazz in
The Parsons Dance Studio
1993, ink on paper, 14" x 11"

10

DRAWINGS IN SPACE

When I first saw my "yellow ball" sculpture...

it felt more like me than anything I had ever created.

It came from a little doodle

fig 10
Lunarblitt XVI
"yellow ball"
1975, stainless steel/aluminum,
72" x 60" x 24"

Since that moment, I have let my lines flow...

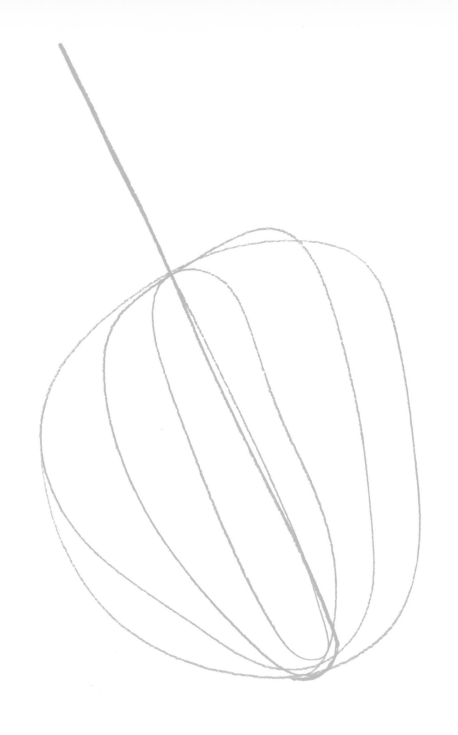

figs 15-18
1979, conté crayon on paper, 14" x 11"

figs 19-26
1993, ink on paper, 8.5" x 5.5"

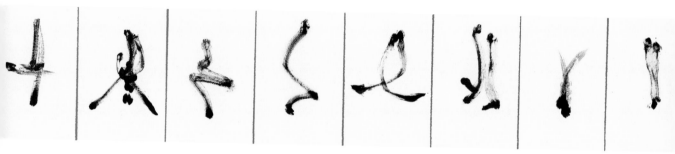

figs 27-34
1992-1993, acrylic on paper, 30" x 22"

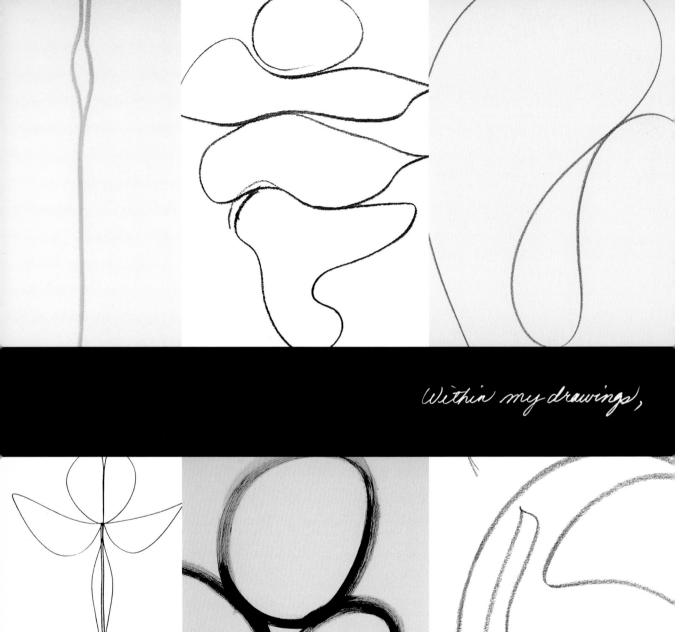

Within my drawings,

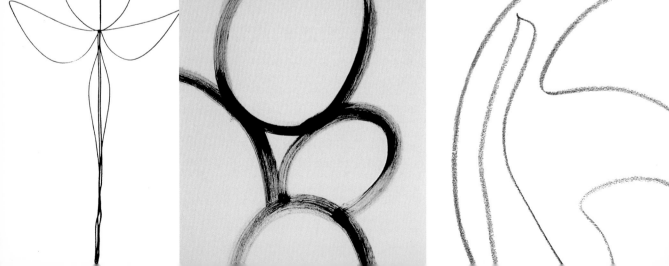

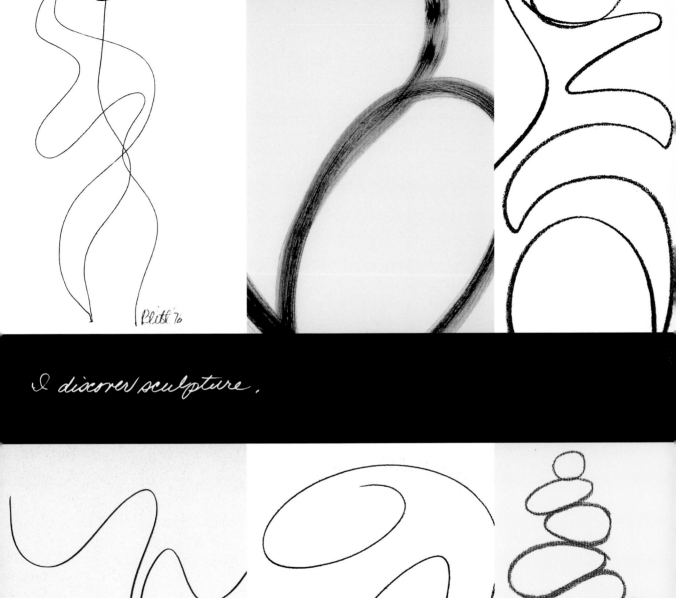

I discover sculpture.

26

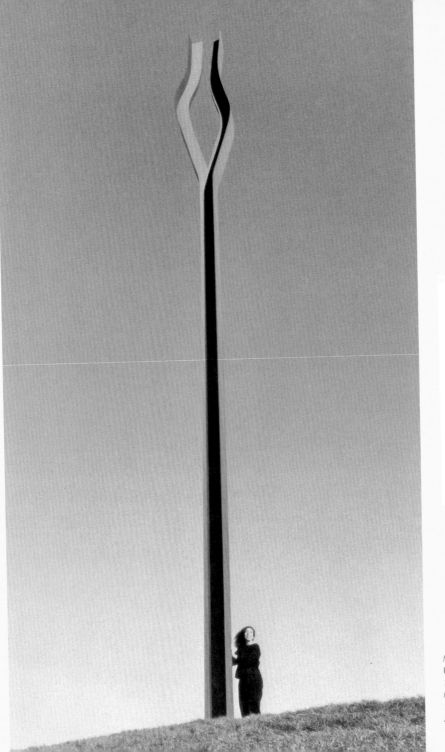

figs 35, 36
One
1984, painted steel,
60 feet x 72" x 24"
1976, pastel on paper,
24" x 18"

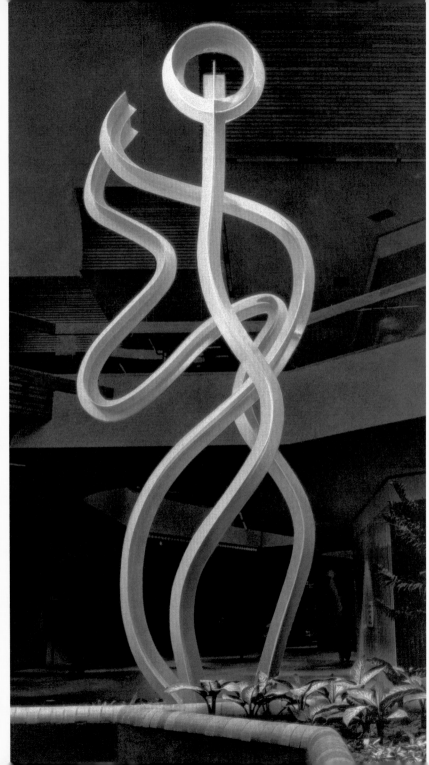

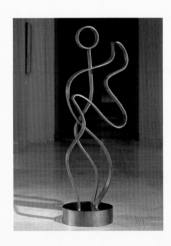

figs 37-39
D a n c i n g
1976, ink on paper, 7" x 5"
1992, bronze,
65" x 24" x 18" - edition 2/3
1980, painted steel,
26 feet x 120" x 60"

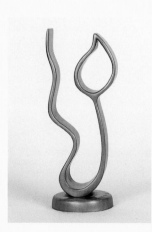

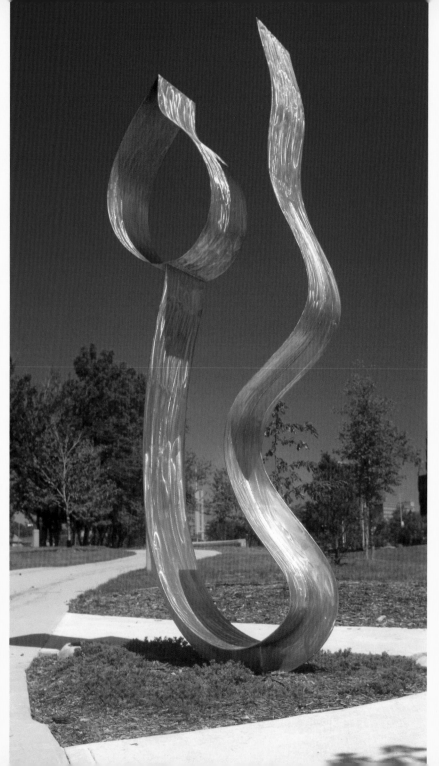

figs 40-42
Spirit's Delight
1986, conté crayon on paper, 24" x 18"
1994, bronze, 11" x 4" x 3" - edition 1/11
1994, stainless steel, 12 feet x 60" x 16"

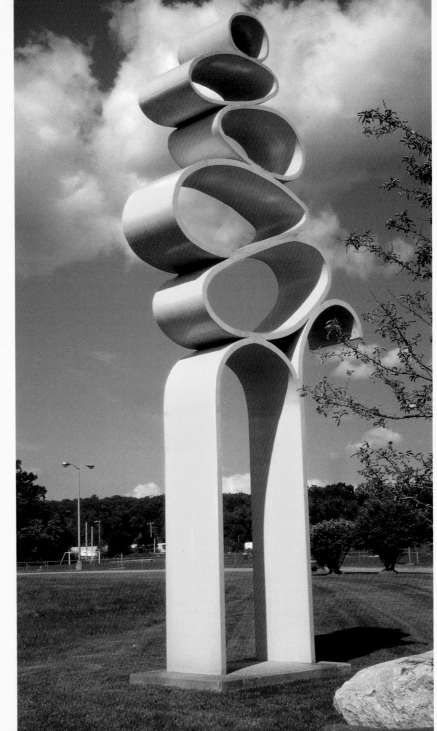

figs 43, 44
Stablitt 55
1976, conté crayon on paper, 13" x 9"
1977, painted steel,
26 feet x 13 feet x 30"

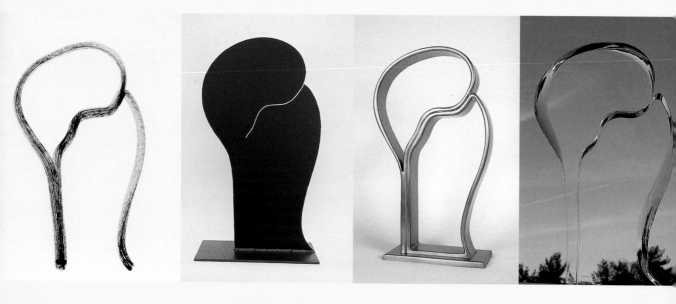

figs 45, 47, 48
I Do
1989, acrylic on paper, 30" x 22"
1989, bronze, 24" x 14" x 3.5" - edition 1/11
1989, acrylic sheet, 24" x 14" x 3"
fig 46
Natural Powers
1990, painted steel, 36" x 16" x 3/8"

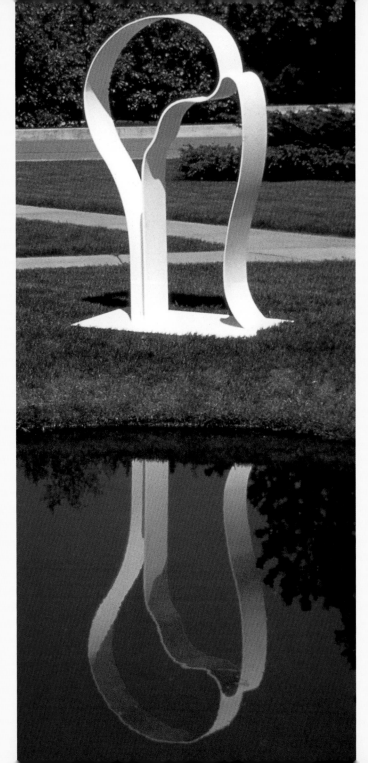

fig 49
I D o
1990, painted aluminum,
77" x 44" x 12"

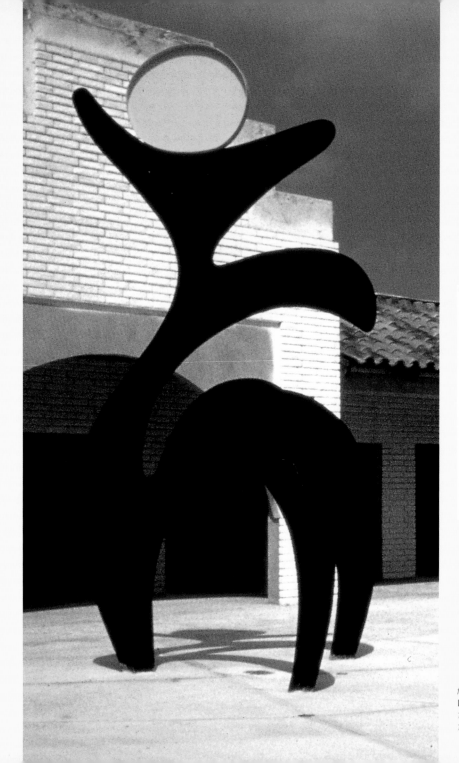

32

figs 50, 51
L i b e r t y
1986, painted steel, 19 feet x 102" x 120"
1986, conté crayon on paper, 14" x 11"

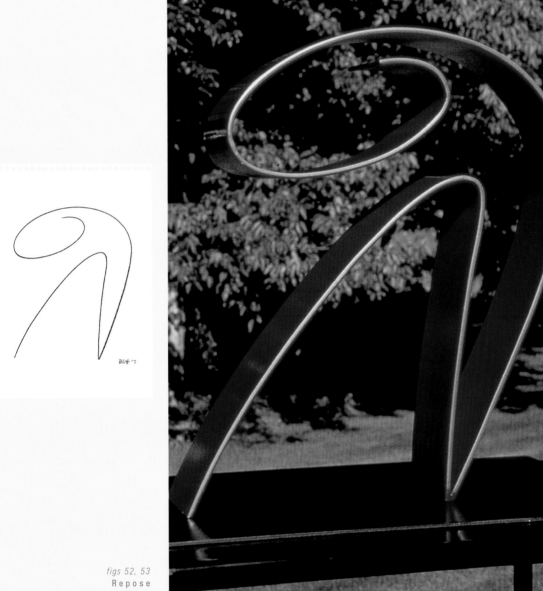

figs 52, 53
R e p o s e
1976, conté crayon on paper, 16" x 14"
1987, painted steel, 23" x 20" x 5"

34

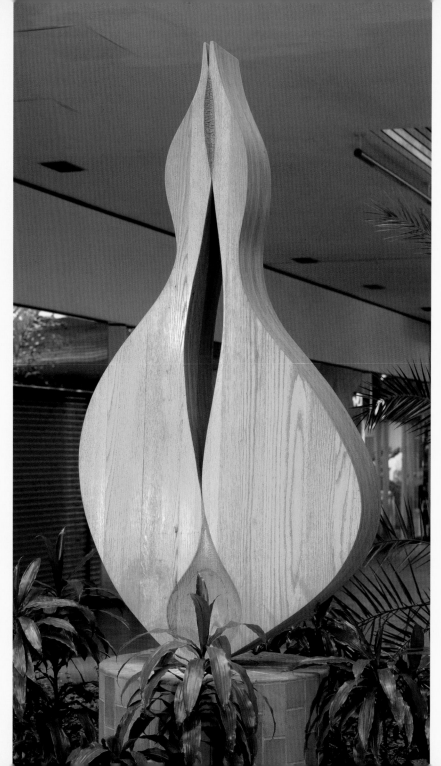

figs 54, 55
Together
1976, conté crayon on paper,
14" x 11"
1980, oak, 96" x 48" x 12"

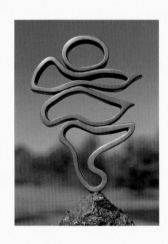

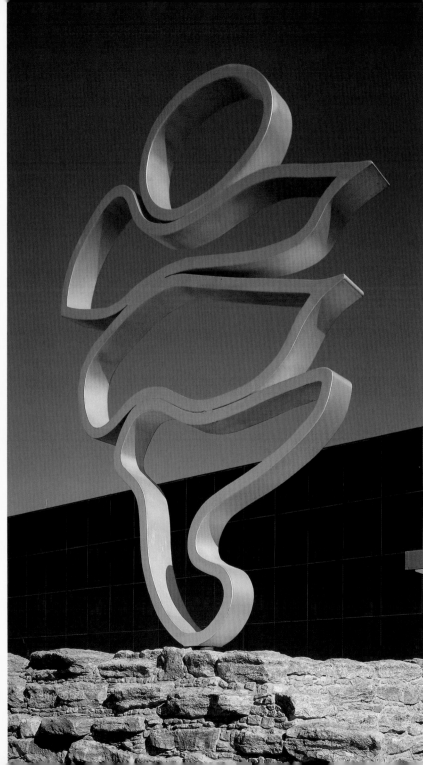

figs 56-58
Inspiration
1987, conté crayon on paper, 24" x 18"
1989, bronze, 15" x 9" x 4" - edition 1/11
1987, painted steel,
26 feet x 18 feet x 18"

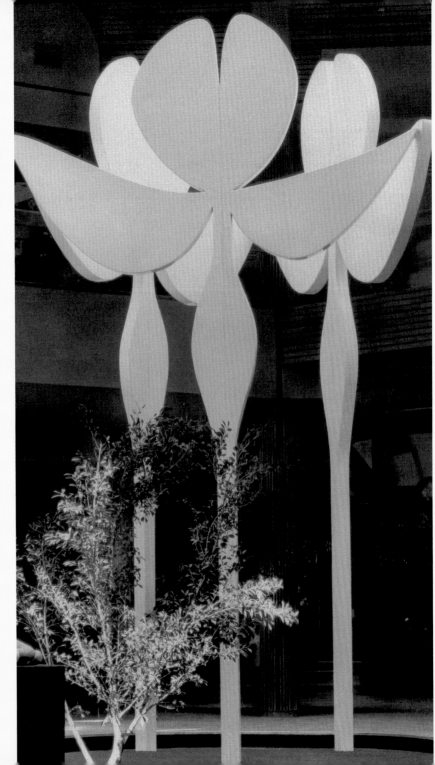

figs 59, 60
Trio
1978, conté crayon on paper, 24" x 18"
1980, painted steel,
26 feet x 15 feet x 14"

I feel like I'm dancing on paper.

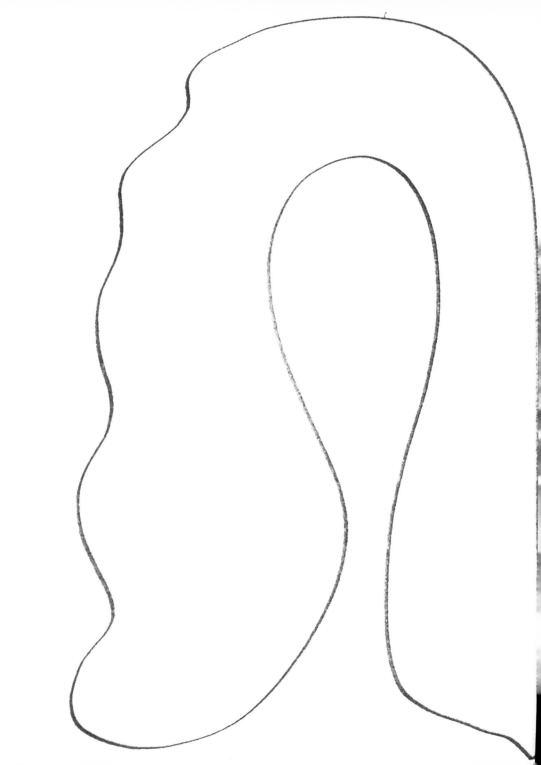

Left hand

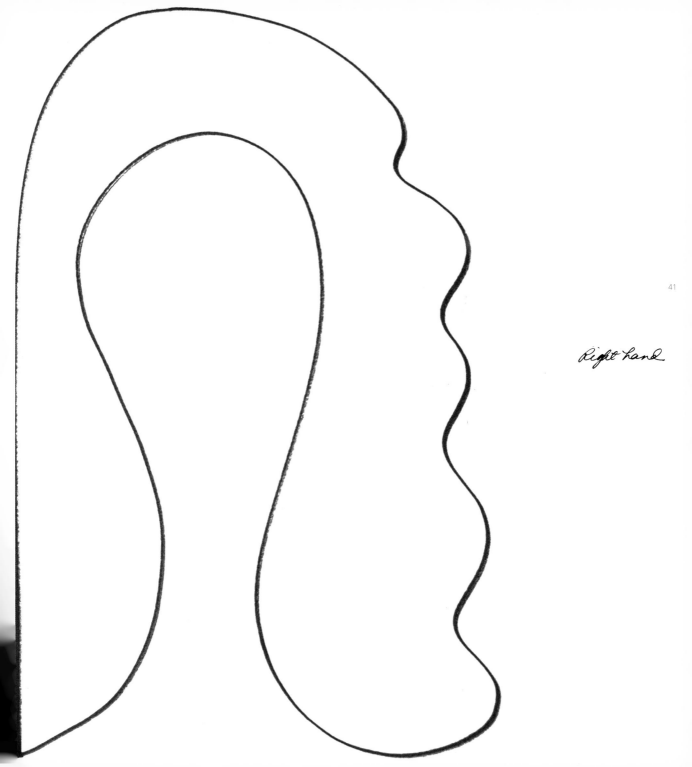

41

Right hand

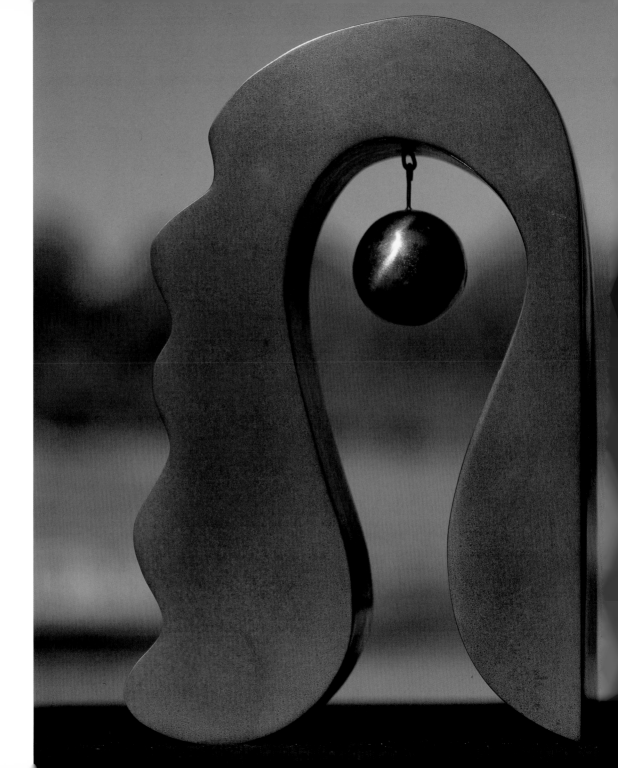

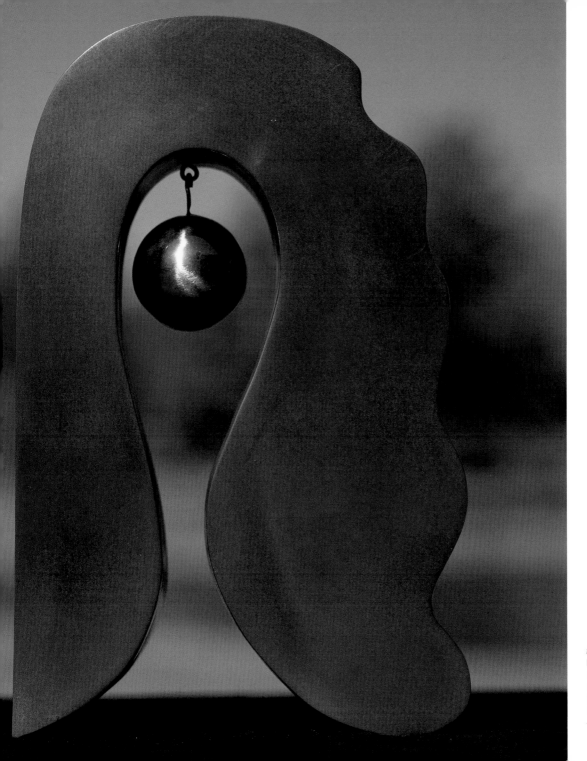

43

44

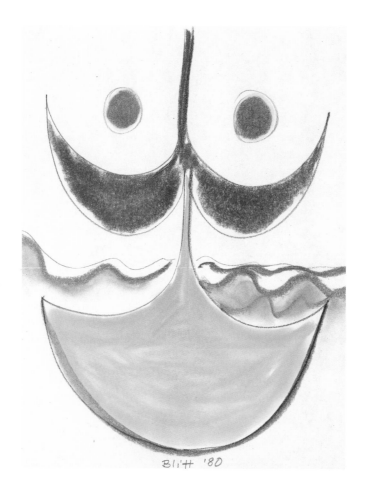

fig 63
Green Eyes
1980, pastel on paper,
14" x 11"

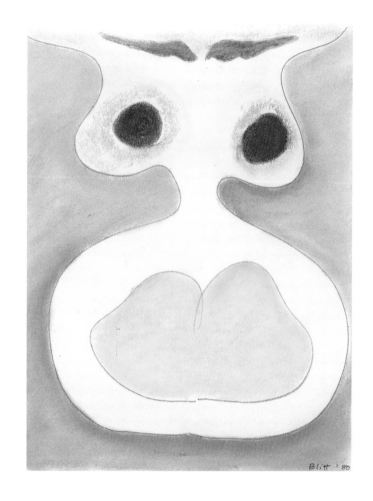

fig 64
R e d E y e s
1980, pastel on paper,
14" x 11"

46

figs 65-71
Pastel On Paper Series
1980-1982
figs 65,66,67,69: 24" x 18"
fig 68: 40" x 25"
fig 70: Unfolding *40" x 30"*
fig 71: 25" x 40"

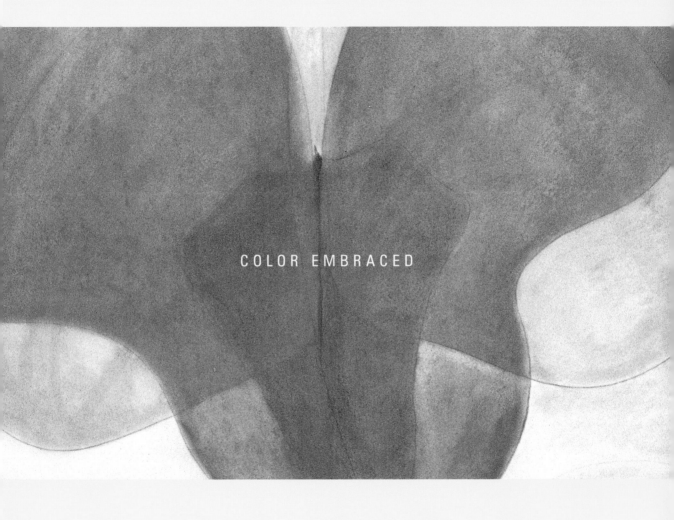

COLOR EMBRACED

detail of fig 70

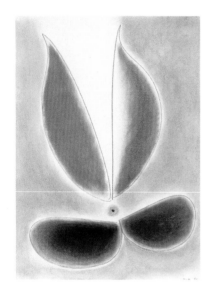

figs 65-67

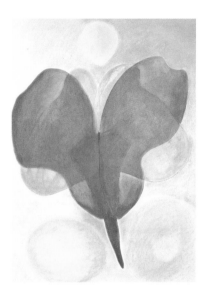

49

figs 68-70

50

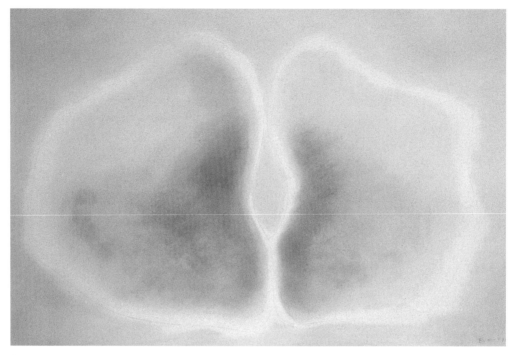

fig 71

figs 72-79
Oval Series
1981-1984
all pastel on paper, 22" x 30"
except fig 77: oil on canvas, 44" x 60"

OVALS

To transmit the spirit
there must be form.
When the form,
and the hands are in
total accord, each forgetting
the other's separate existence,
then the spirit will reside in
your work. Tung Chi Chung

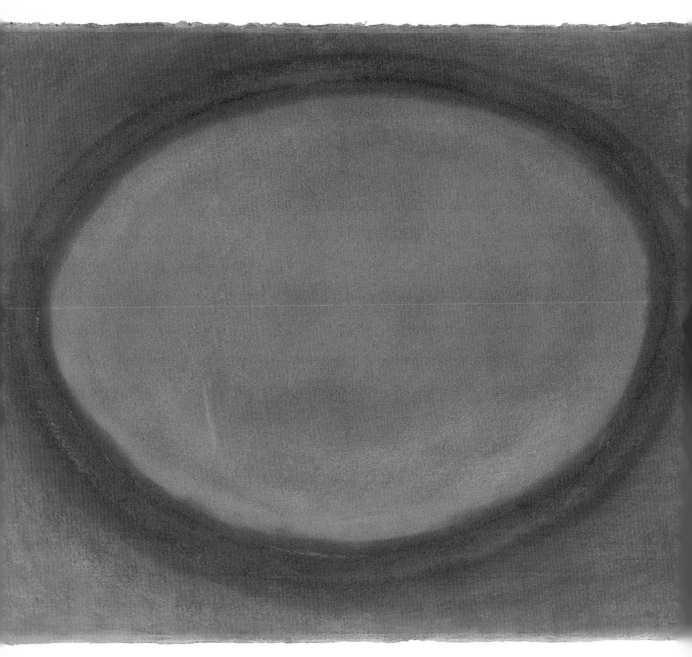

fig 72

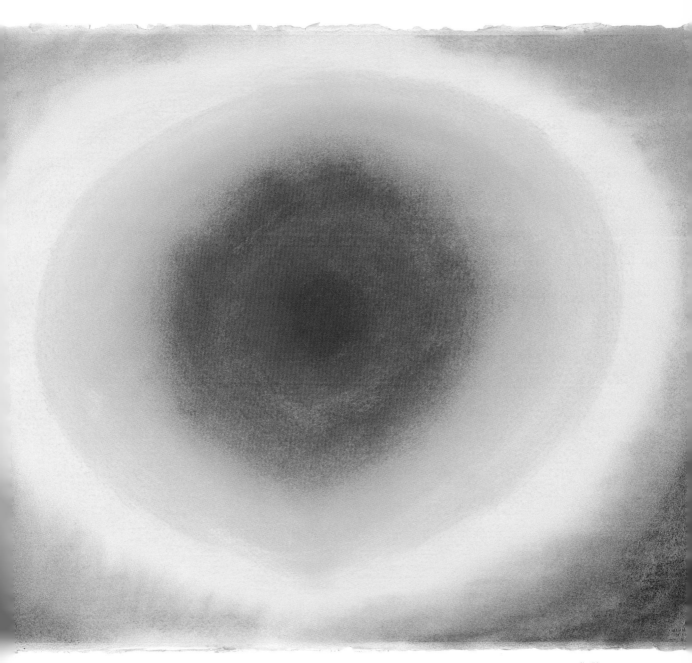

fig 73

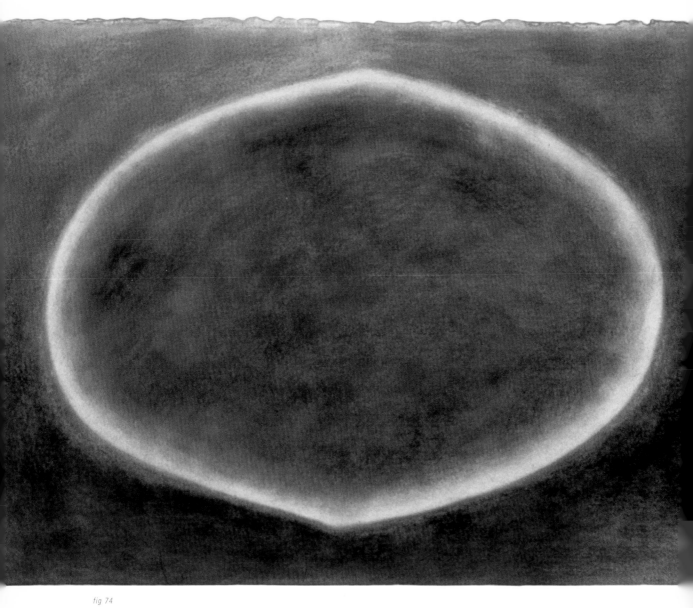

fig 74

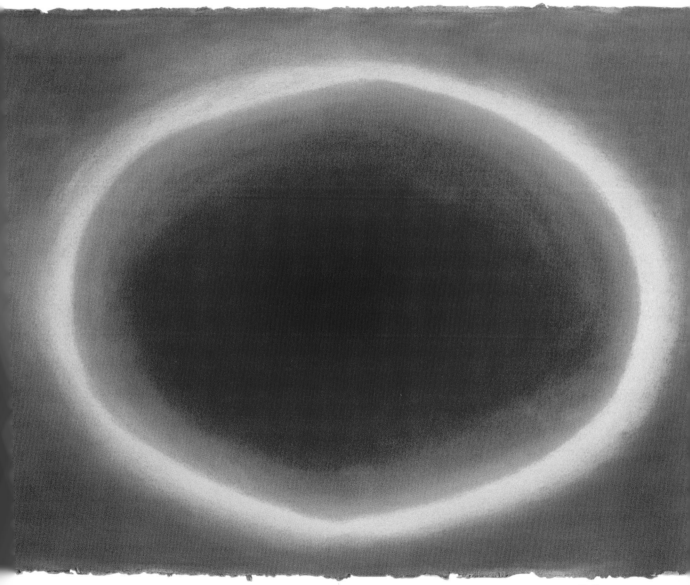

fig 75

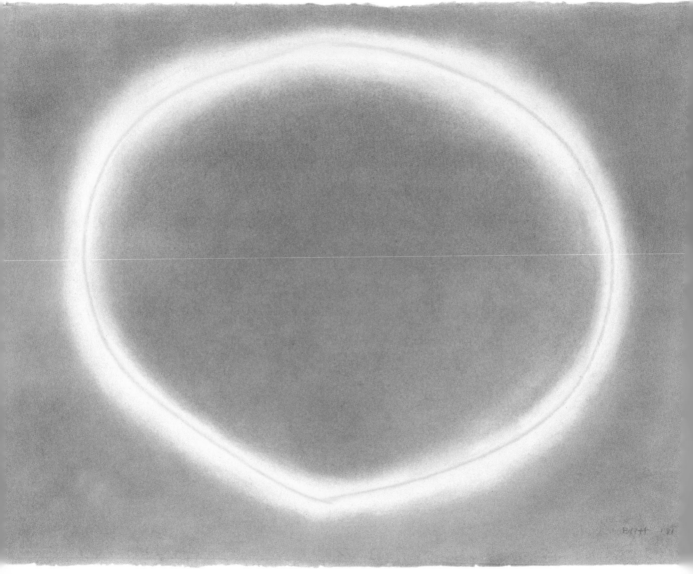

fig 76

fig 77

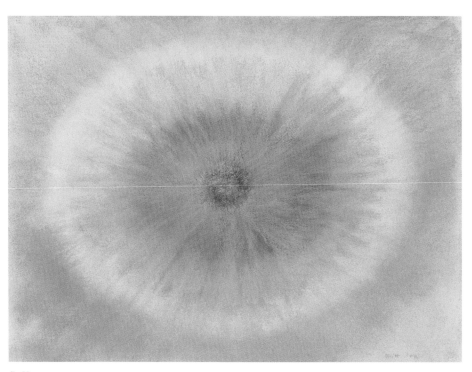

fig 78

fig 79

Music is activated when you approach . . .

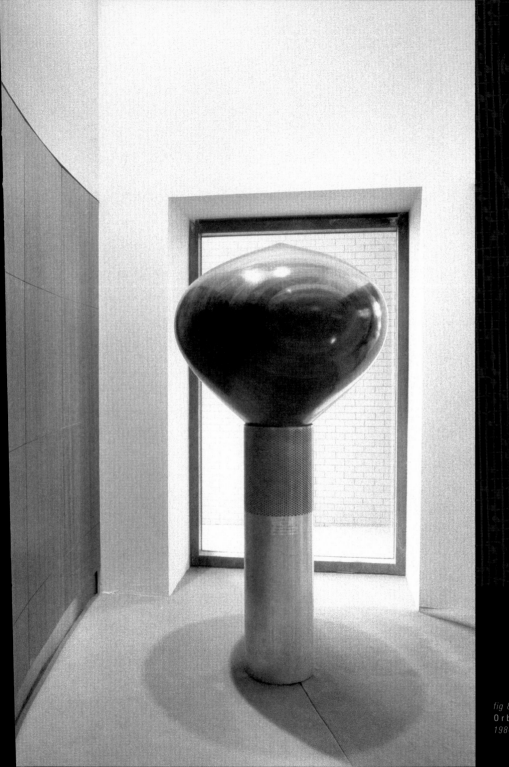

fig 8
Orb
1984

and when you sit.

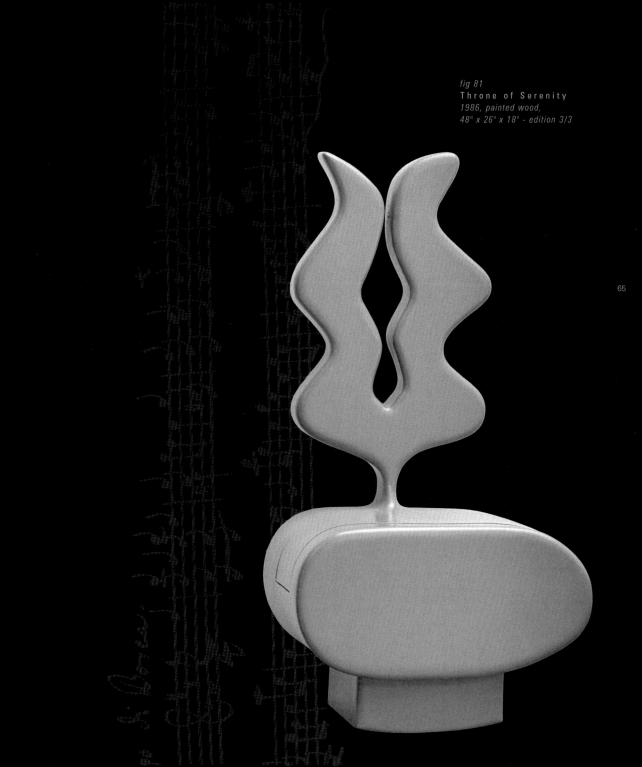

fig 81
Throne of Serenity
1986, painted wood,
48" x 26" x 18" - edition 3/3

*I was inspired by the
Music of Mario Lavista
and his use of quotes from
Li Po poetry (701-763 a.d.)*

LI PO POETRY

The setting sun about to vanish west of the Hsien Hill,
Lost among the flowers, I wear a hat upside down. Li Po (701-762)

Blitt '84

fig 82

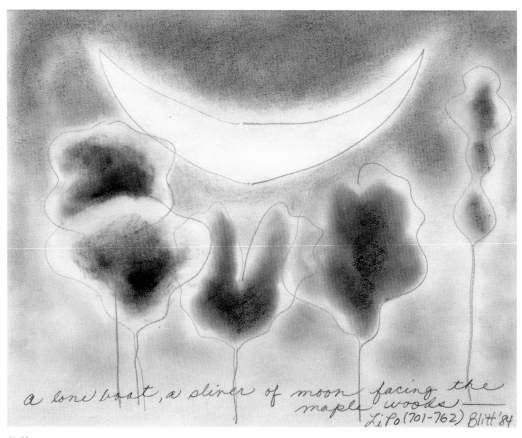

a lone boat, a sliver of moon facing the maple woods —
Li Po (701-762) Blitt '84

fig 83

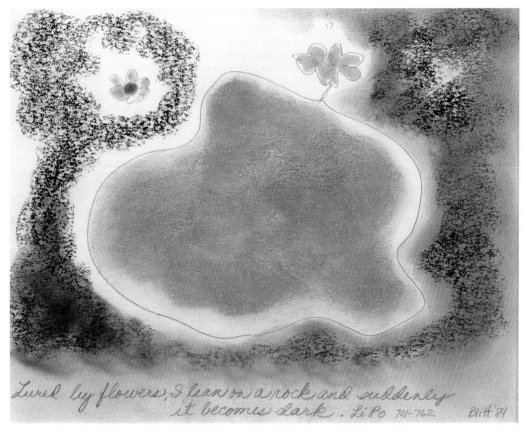

Lured by flowers, I lean on a rock and suddenly
it becomes dark. Li Po 701-762 Blitt '81

fig 84

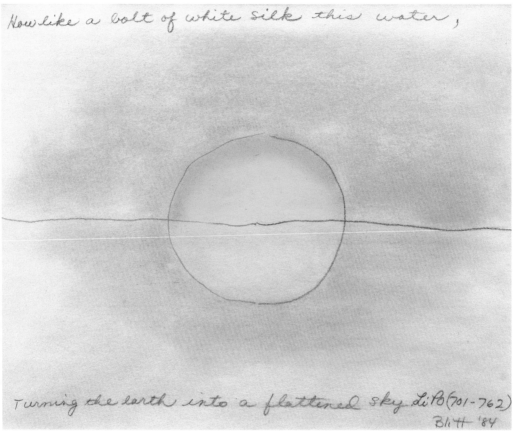

How like a bolt of white silk this water,

Turning the earth into a flattened sky. Li Po (701-762)
Blitt '84

70

fig 85

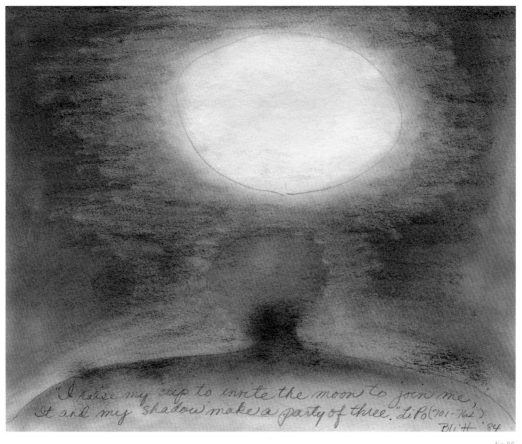

"I raise my cup to invite the moon to join me; It and my shadow make a party of three." Li Po (701-762) Bli H. '84

fig 86

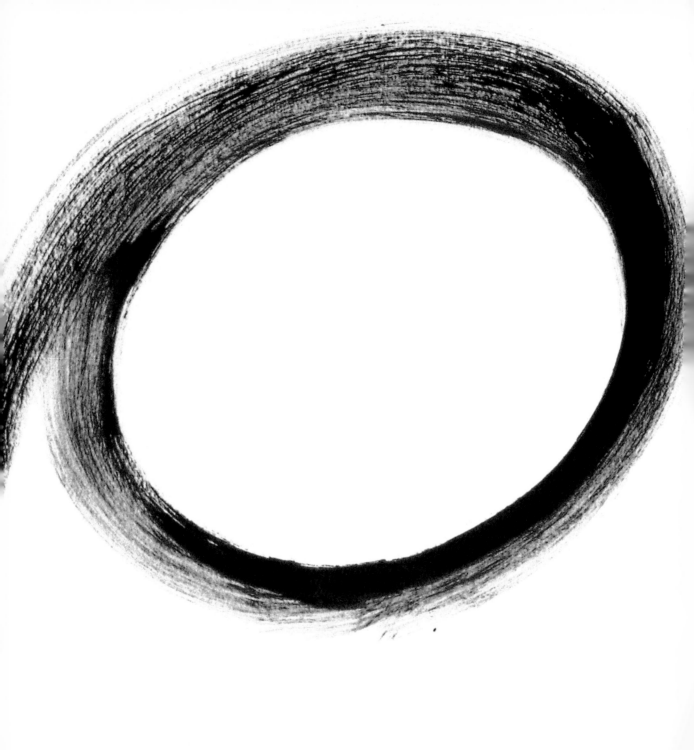

BLACK BOX

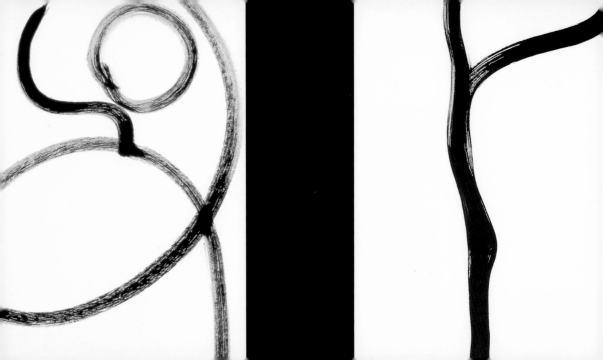

Dividing the rectang

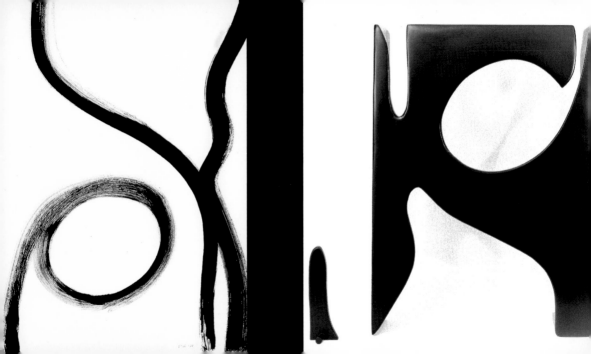

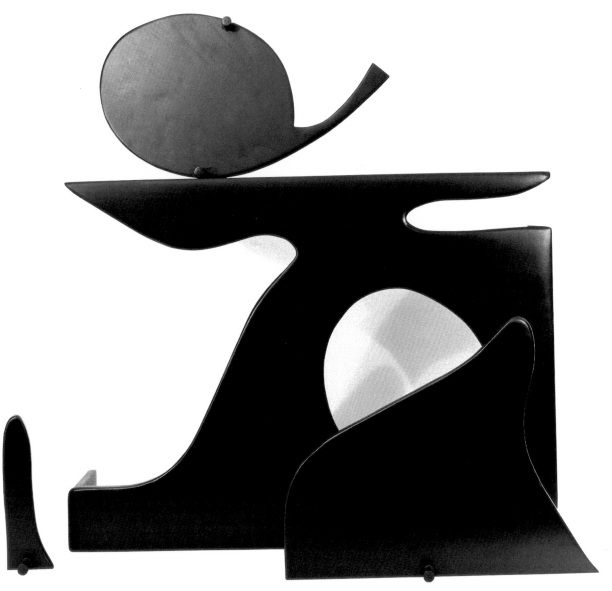

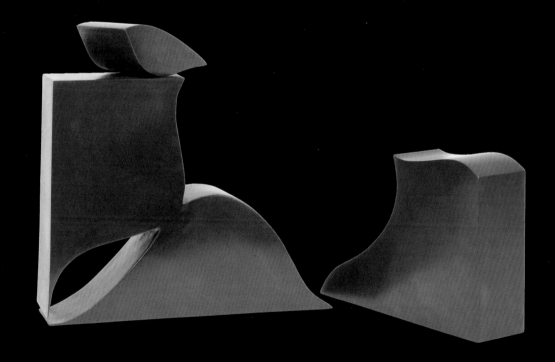

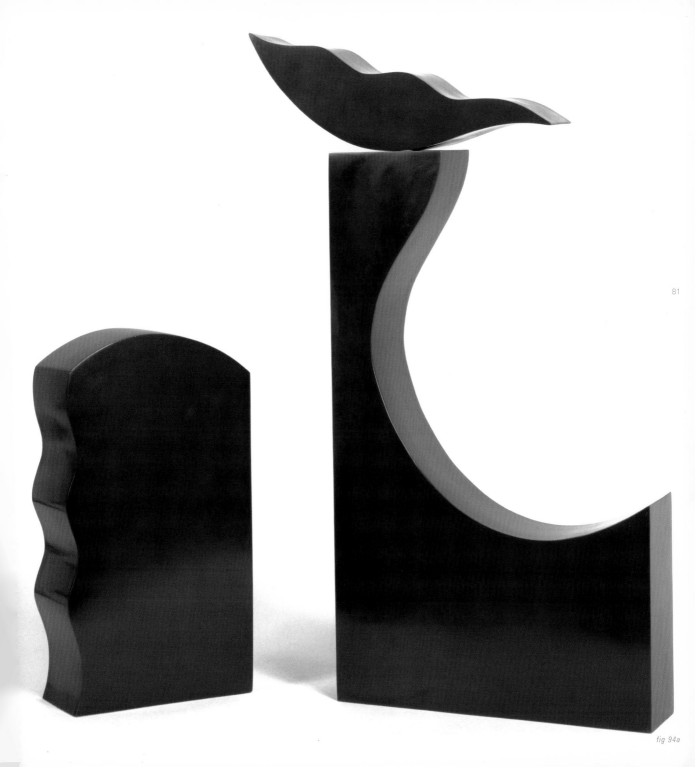

fig 94a

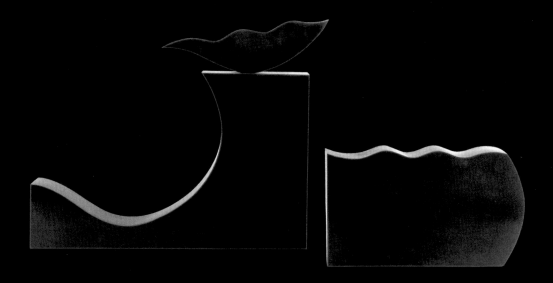

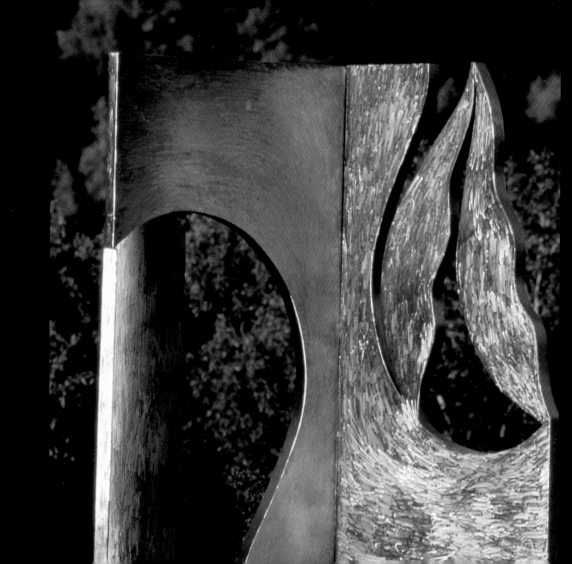

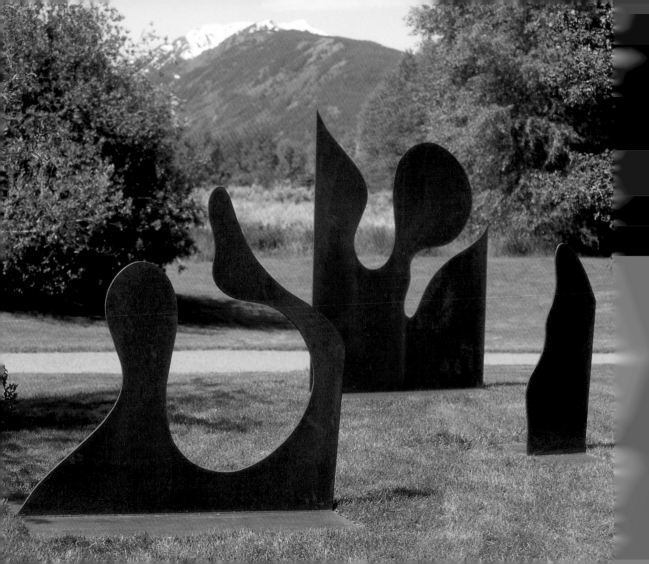

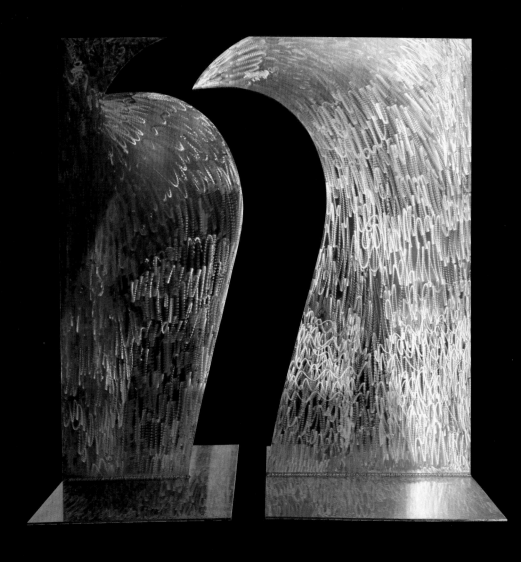

fig 97

Black Box VIII, Fleeting Passion or True Love
1991, aluminum, 84" x 84" x 48"

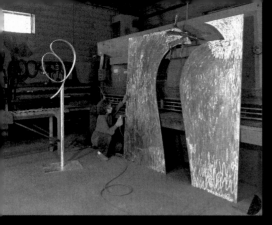

fig 98
H a r m o n y
1991, aluminum, 84" x 22" x 5"

86

figs 99-108
C h i P a i n t i n g s
1995-1996, acrylic on paper, 30" x 22"
except
C h i T r i p t y c h s
figs 101, 106: 1990, acrylic on paper, 30" x 66"
C a u g h t # 1
fig 107: 1995, acrylic on paper, 30" x 22"

CHI

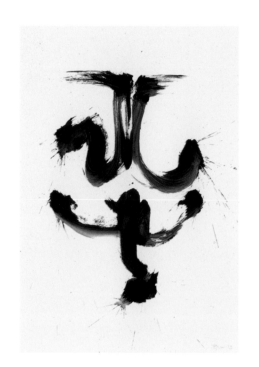

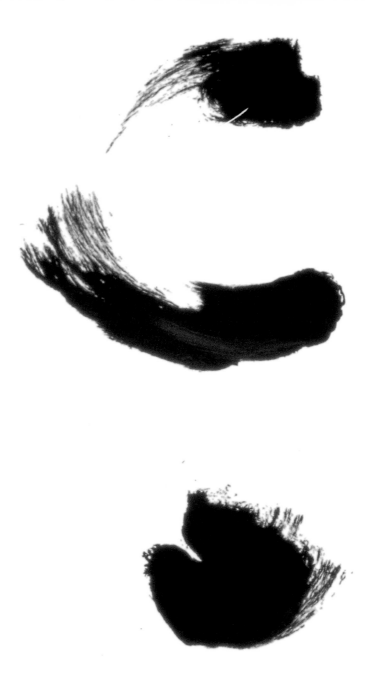

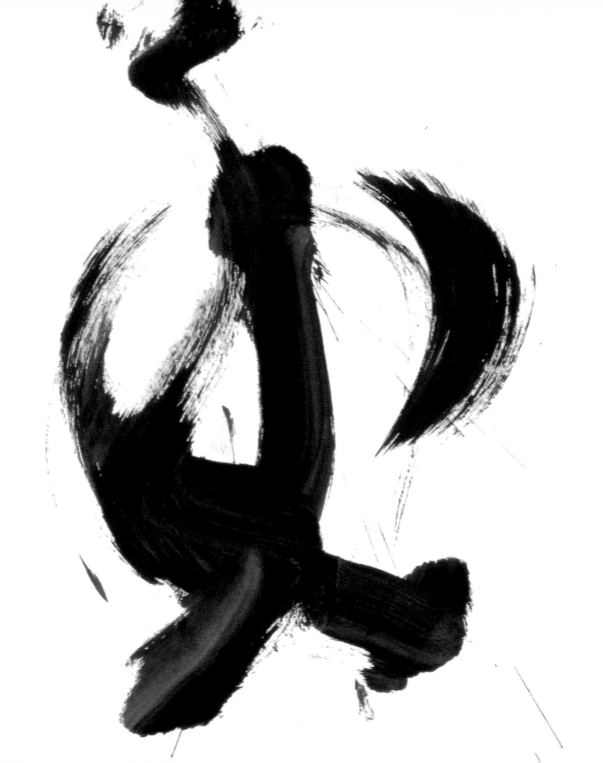

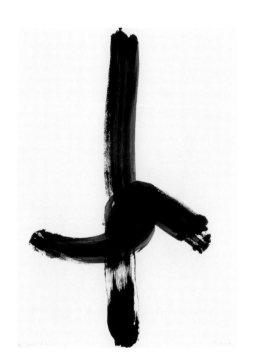

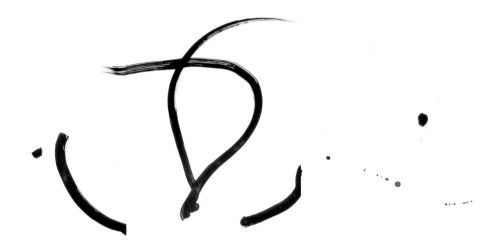

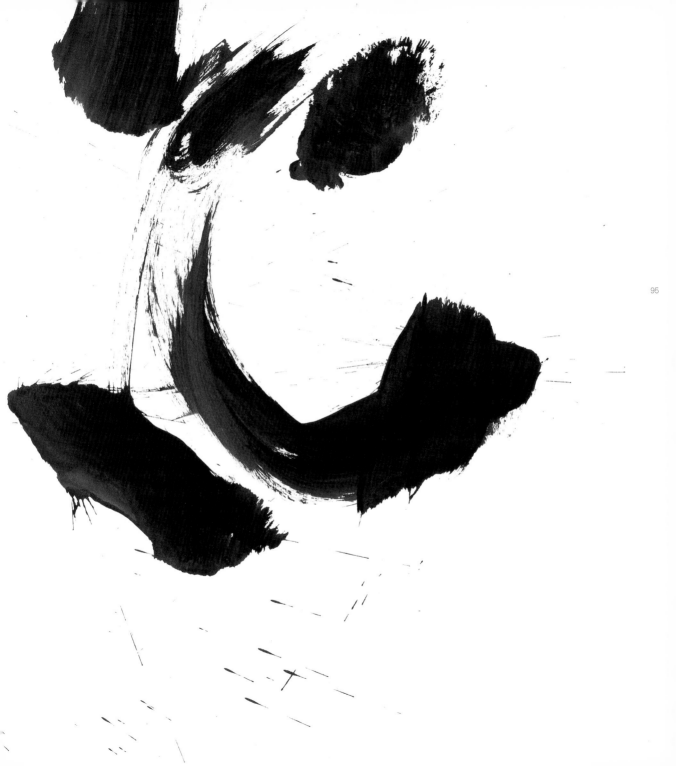

BI: H '95

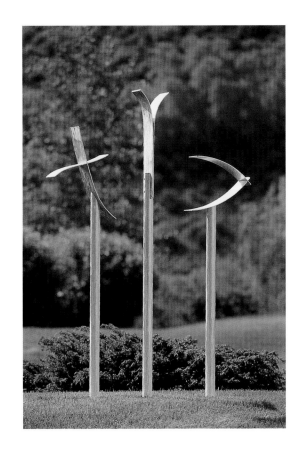

fig 109
R e a c h i n g O u t F r o m W i t h i n
1991, aluminum, 72" x 60" x 26"

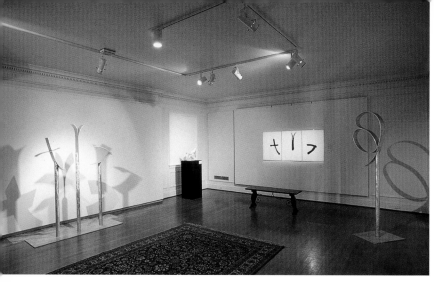

fig 110
"Reaching Out From Within:
The Art of Rita Blitt"
1991, Albrecht-Kemper Museum of Art,
St. Joseph, Missouri

ICELAND

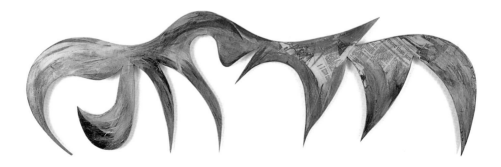

fig 111
Captivity
1995, acrylic/laminated newspaper
on masonite, 16" x 52"

17 foot waves and the

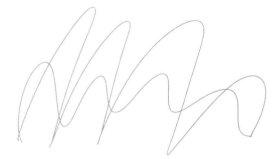

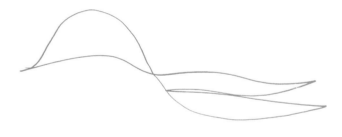

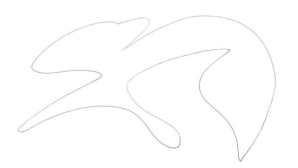

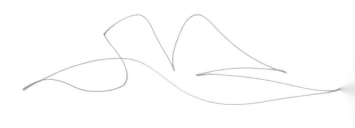

rocking of the ship ...

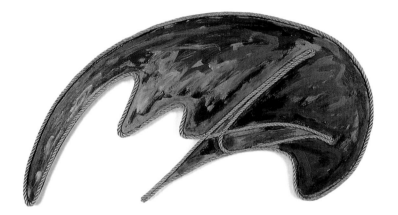

fig 112
Gentle Turbulence
1995, acrylic on masonite, 22" x 42"

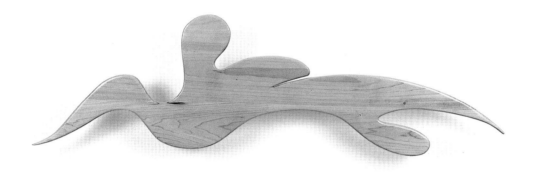

fig 113
Flight of Fancy
1995, wood, 20" x 72" x 3/4" - edition 1/3

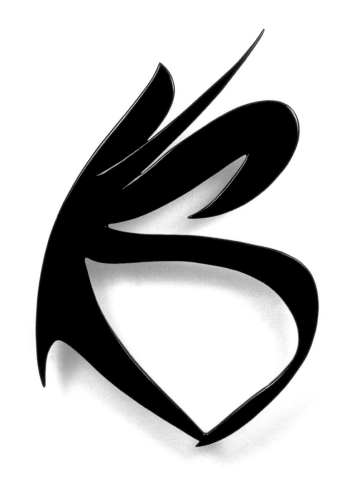

fig 114
Silent Energy
1995, stained wood, 50" x 40" x 3/4" - edition 1/3

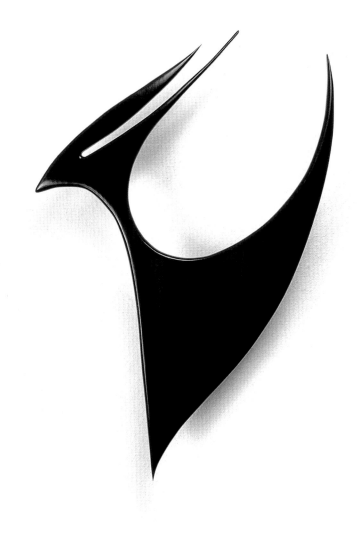

fig 115
Joyous Moment
1995, stained wood, 38" x 23" x 3/4" - edition 1/3

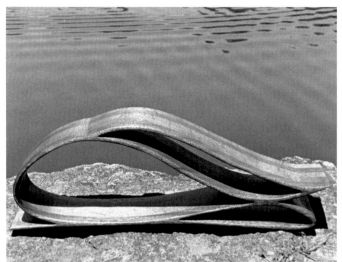

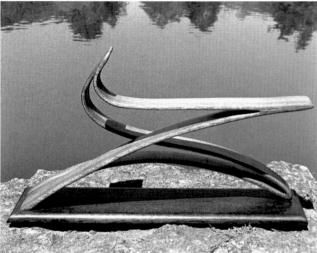

fig 116
Iceland Solitude
1993, wood, 9" x 22" x 7"

fig 117
Iceland Outreach
1993, wood, 14" x 26" x 6"

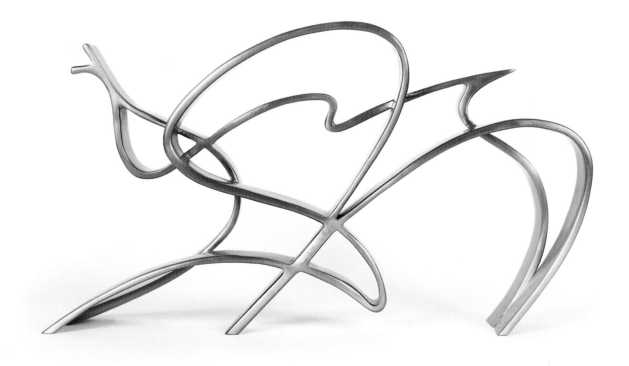

fig 118
Iceland Surge
1993, bronze,
13" x 24" x 4" - edition 1/11

fig 119
Mozart
1995, oil on canvas,
52" x 60"

fig 120
Detail of Bach Suite (A)
1995, oil on canvas, 52" x 60"

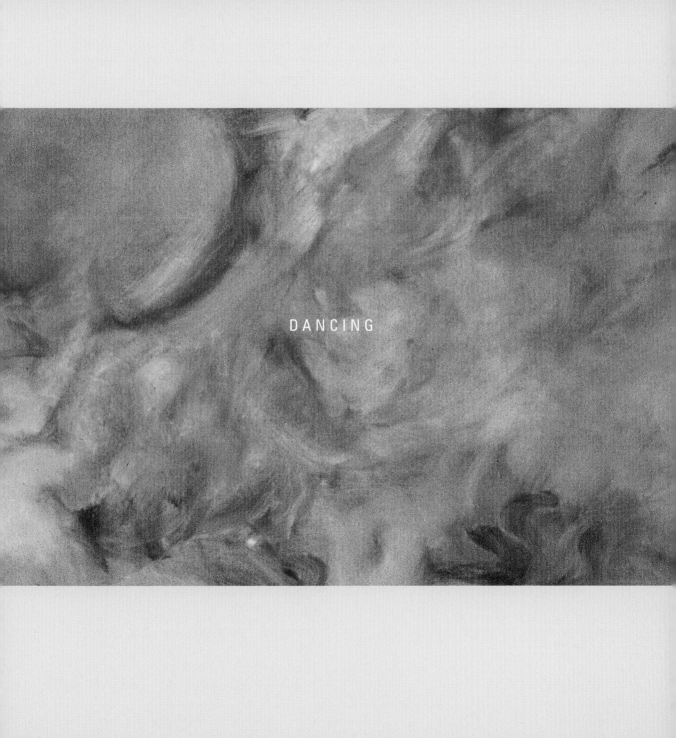

DANCING

fig 121
Bach Suite (B)
1995, oil on canvas, 52" x 60"

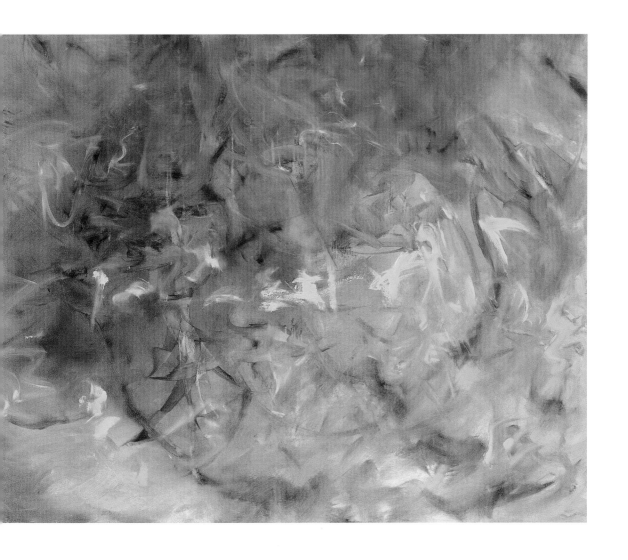

fig 122
B a c h S u i t e (C)
1995, oil on canvas, 52" x 60"

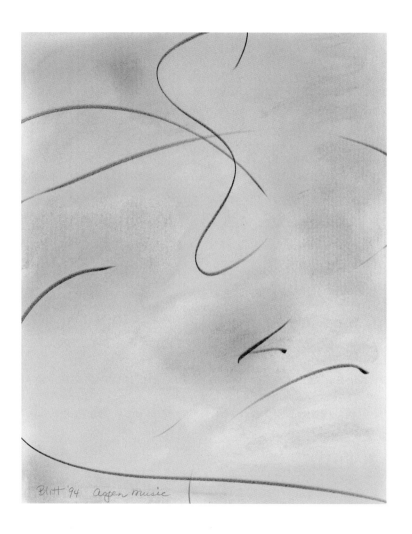

fig 123
Aspen Music
1994, pastel on paper, 14" x 11"

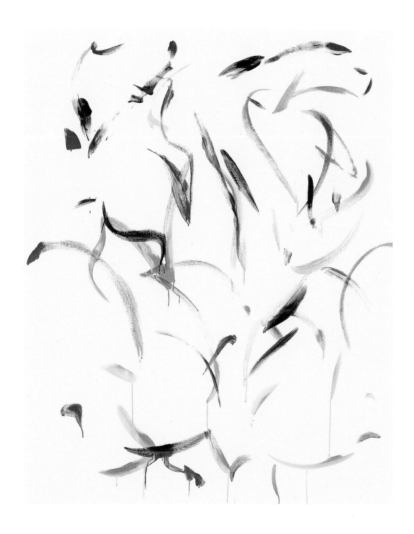

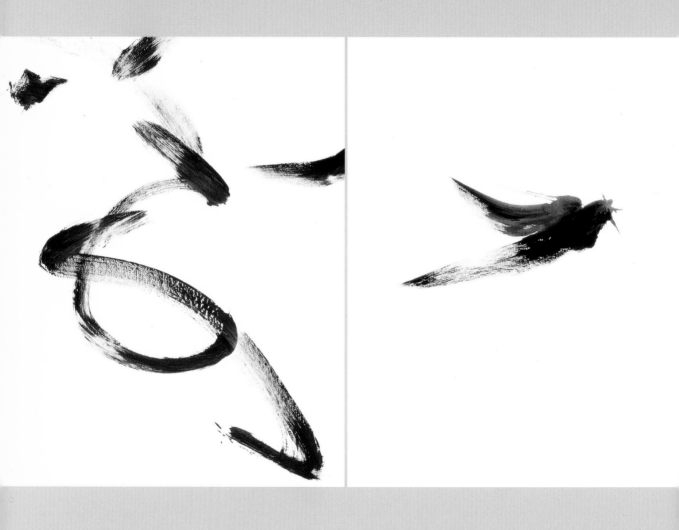

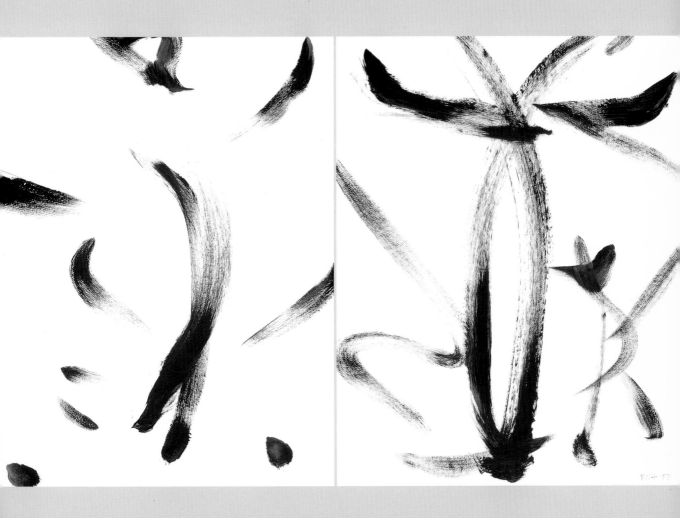

figs 125, 127, 128
After the Ballet
1997, acrylic on paper, 30" x 22"
fig 126
Sacred Moment
1997, acrylic on paper, 30" x 22"

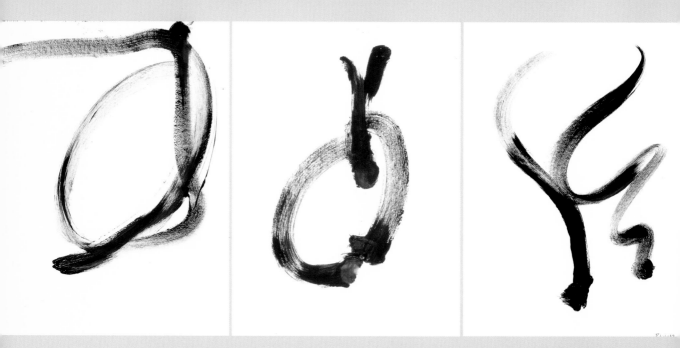

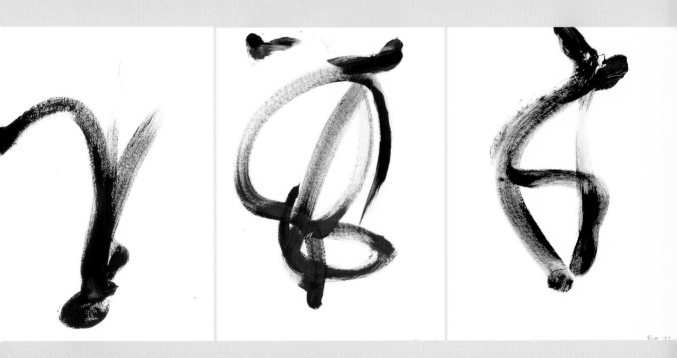

figs 129-134
1997, acrylic on paper, 30" x 22"

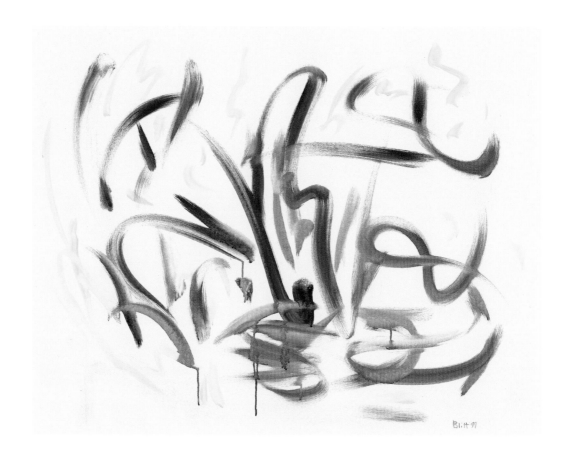

fig 135
Chopin
1999, oil on canvas,
39" x 50"

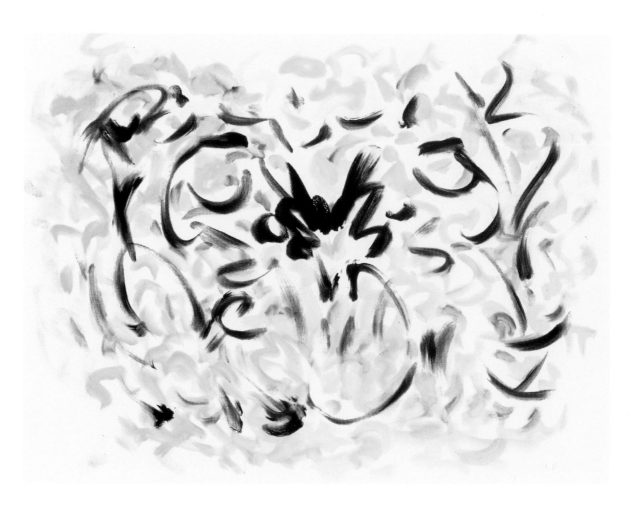

fig 136
Beethoven
1999, acrylic/oil on canvas,
50" x 67"

120

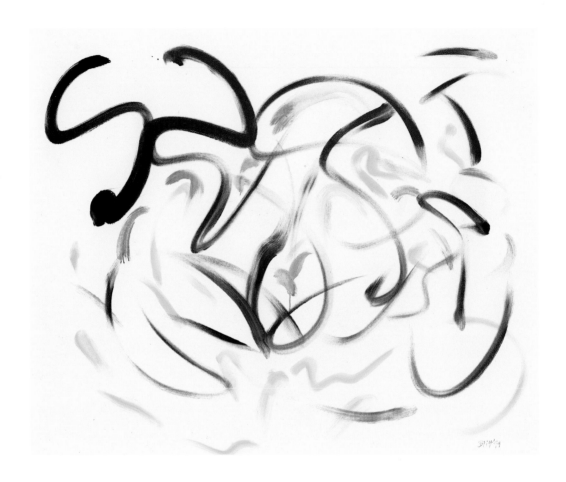

fig 137
Fire Bird
1999, acrylic/oil on canvas,
50" x 60"

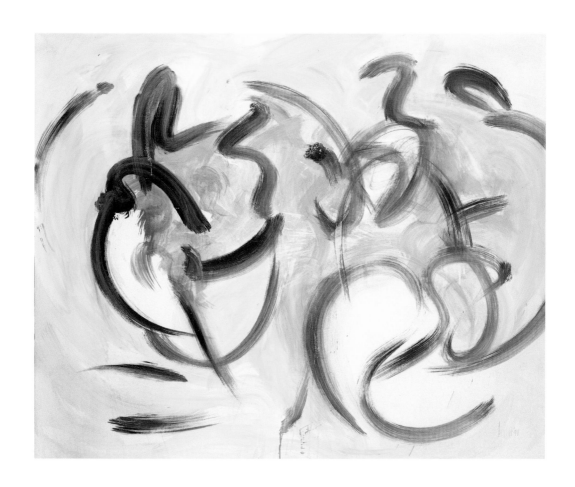

fig 138
Improv
1999, acrylic/oil on canvas,
48" x 60"

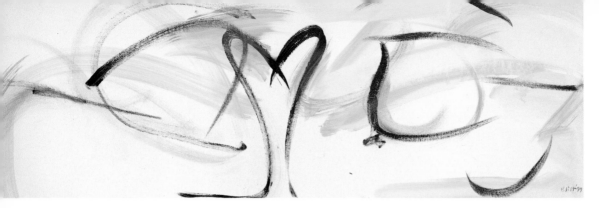

fig 139
Serendipity
1999, acrylic/oil on canvas,
52" x 16"

fig 140
Hope
1996-97, acrylic/oil on canvas,
72" x 60"

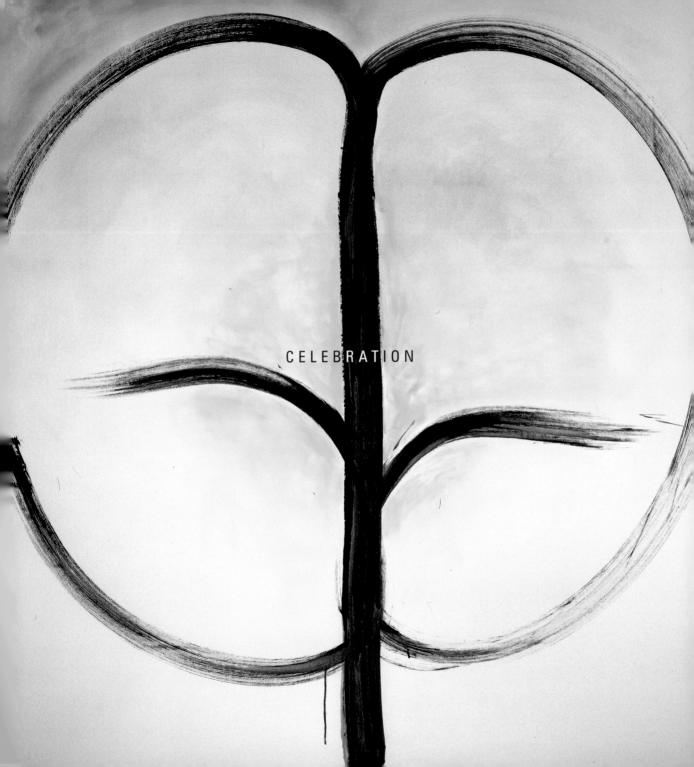

CELEBRATION

fig 141
Affirmation
1998, acrylic on canvas, 48" x 60"

fig 142
Serenity
1998, acrylic on canvas, 50" x 61"

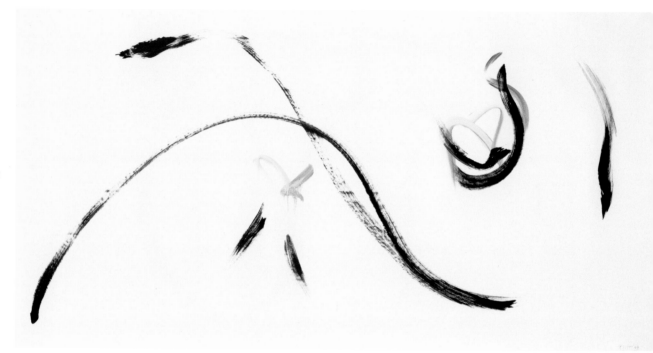

fig 143
Leap of Faith
1998, acrylic on canvas, 53" x 102"

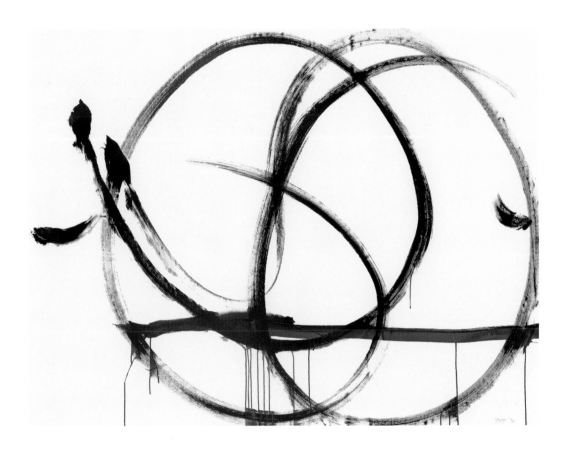

fig 144
Around and Round
1996, acrylic on canvas, 50" x 68"

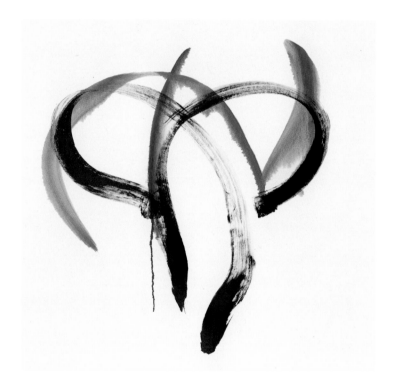

fig 145
Freedom
1998, acrylic/oil on canvas, 44" x 46"

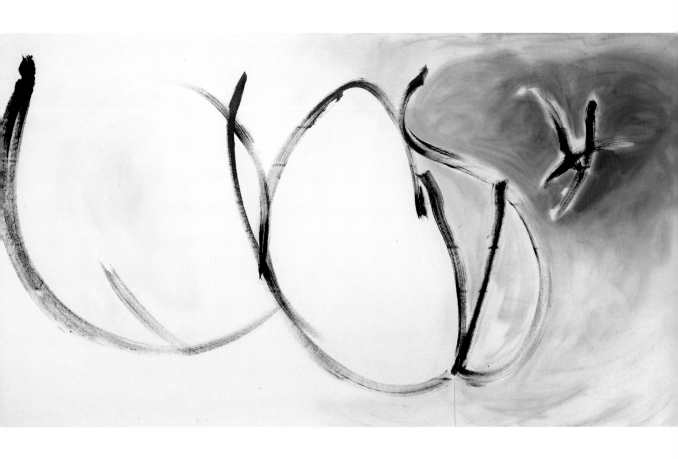

fig 146
Aspen Dawn
1996-97, acrylic/oil on canvas, 71" x 129"

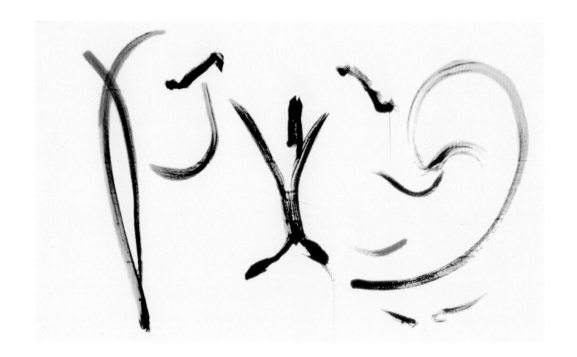

fig 147
C e l e b r a t i n g D o r i a n n a
1996, acrylic on canvas, 70" x 118"
fig 148
C e l e b r a t i n g D o r i a n n a
1997, color added, acrylic/oil on canvas

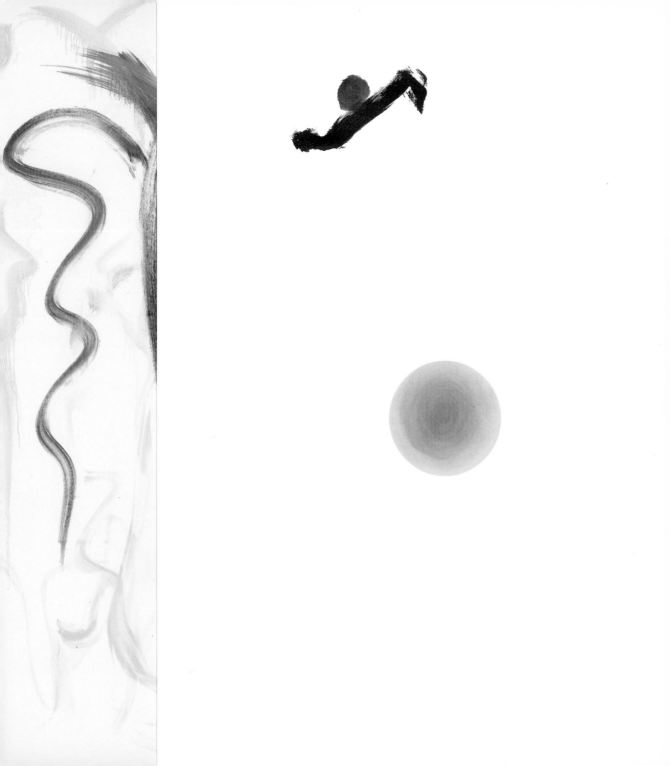

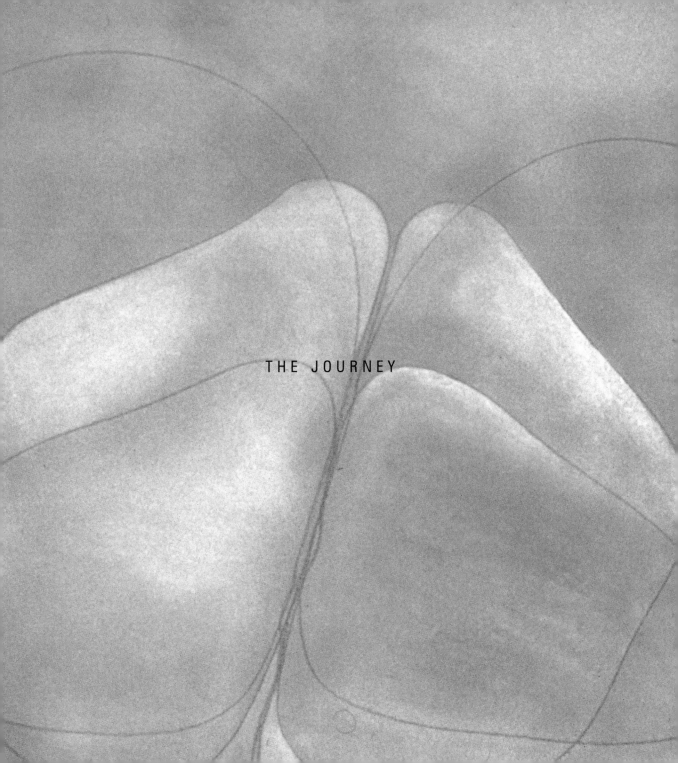

THE JOURNEY

Birthday Card
for Mom
1941
crayon on paper,
5" x 4"

"Yellow ball"
makes its first
appearance.

Hallelujah
1942, watercolor
on paper, 14" x 11"

Rita Copaken
photograph,
1941

"Nicedomus"
1942, pastel [
paper, 12" x 9[

What began as r[
self-portrait bec[
an African-Amer[
boy. [RB]

134 This timeline chronicles Rita Blitt's inner journey as a developing artist and the events that have shaped her life. Blitt quotes, gathered from personal interviews, 2000, are noted with the initials RB.

Excerpts from the following unpublished essays are identified with the author's initials:

RM Robert McDonald, writer, critic and curator. "The Art of Rita Blitt." 1998.

BN Bezalel Narkiss, Ph.D., recipient of the Israel Prize of 1999, Professor of Art History and founder of the Center for Jewish Art at Hebrew University, Jerusalem, Israel. "The Jewish Art of Rita Blitt." 1998.

SR Shulamit Reinharz, Ph.D., Professor of Sociology, Director of the Women's Studies Program, Director of the Hadassah International Research Institute on Jewish Women and Director of the Women's Studies Research Center, Brandeis University. "Political Issues in the Work of Rita Blitt." 1998.

Compiled by Megan Semrick, project editor

1931
September 7: Rita Copaken is the first baby born at the new Menorah Medical Center, Kansas City, Missouri.

1934
Rita's grandfather, Isaac Sofnas, a Russian-immigrant designer of embroidery patterns, draws flowers at the end of letters he sends from New York. Rita exchanges drawings with him.

Perhaps my lines continue his. [RB]

1939
Responding to news of Jewish suffering in Europe, Rita's mother, Dorothy Sofnas Copaken, works with Hadassah to help establish Israel as a national Jewish homeland. A realtor and part-time inventor, Rita's father, Herman Copaken, demonstrates to his children the value of patience, determination and self-motivation.

"Mr. and Mrs. Copaken instilled in their children (Rita, Shirley White and Paul Copaken) an awareness of and caring for the world, which Rita expresses through her art." [RM]

1941-1943
"Among her earliest surviving works are a watercolor and several pastels of African-Americans. In the early watercolor, a seemingly happy girl sings and sways. She dances to music. Her arms reach out to embrace the world. Intuitively, 10-year-old Rita created a naive, conceptual artwork, referring to the visual arts, music and dance (fig. 151).

fig 154　　　　　　　　fig 155　　　　　　　　fig 156

Imaginary Landscape
1946, watercolor on paper, 8.5" x 15"

Scene from our Back Door
*1946, tempera paint on paper,
17" x 14"*

*Painted in
celebration of
the birth of
Blitt's
nephew, Jerry
White.*

Kabibi Choo Choo
1951, oil on canvas, 16" x 20"

"Considering the times, the pre-Civil Rights era when segregation and degradation were prevalent, it is noteworthy that Blitt as a pre-teen painted empathetic portraits of African-Americans. Her youthful awareness and opposition to segregation is indicative of the humanistic philosophy rooted in her heritage, which provides a recurrent theme in her work." [RM]

One of my fondest memories of grade school is the sight of fresh drawing paper being passed out.

I loved drawing trees formed with multiple lines, each emanating from the roots and continuing up through the trunk to become branches and twigs. No line was added that did not grow from the roots. So my trees felt alive. [RB]

Rita receives a scholarship for Saturday classes at the Kansas City Art Institute, Kansas City, Missouri. The teacher invites Rita to her home to encourage her artistic development, as does her fifth grade teacher.

1944-1948
After winning a $100 first place prize in a statewide greeting card design contest, 13-year-old Rita takes her portfolio to show at Hallmark Cards. She doesn't get past the receptionist.

Rita's art is displayed for the first time in public when her painting is selected for a *National Scholastic Magazine* art competition.

Her senior year in high school, she visits the University of Illinois and meets Irwin Blitt.

1949-1950
At the University of Illinois, in the life drawing class of John Raushenberger, Rita's lines become spontaneous through the discipline of drawing quick figure poses.

The speed with which I learned to draw the human body prepared me for a life of gestural drawing. [RB]

Rita encounters the work of abstract expressionists, including Jackson Pollock.

I wanted to like non-objective paintings, but I couldn't allow myself to do so until I discovered through my own experience in art that it was honest. Becoming a sculptor in the 60s freed me from subject matter, allowing abstract expressionism to naturally evolve in my work. [RB]

"Her cautious interest in the New York School was relatively enlightened, compared to the hostility of some, who felt that abstract painting might be a form of psychological warfare undermining the country from within." [RM]

Rita's first sculpture, readily produced, is praised and photographed. The second one, self-consciously made after the mysterious success of the first, is thrown back into the clay barrel.

After completing two years at the University of Illinois,

135

Missing Parts from our Torso Lamp
1951, oil on masonite, 12" x 36"

Dancing lines make their first appearance.

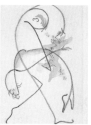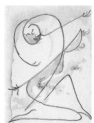

Untitled
1952, watercolor/conté crayon on paper, 8" x 5"

136

Rita transfers to Kansas City University (now University of Missouri-Kansas City), majoring in art and minoring in education.

1951-1954
Rita marries Irwin Blitt. Throughout her career, Irwin is a constant source of unconditional support.

When I was discouraged, he said 'Your work is good and you know it!' When I was frustrated, he said 'Paint!' and I did. When I wanted to give up, he looked into my eyes and said 'You can do it.' RB

Blitt completes work towards her degree in the summer of 1951. She teaches kindergarten for a year followed by pre-school for another year.

Blitt attends weekly painting classes at the Kansas City Art Institute, where she studies with Wilbur Niewald, an admirer of Paul Cézanne.

Niewald taught me to see the beauty of shapes as they relate to one another. I'll never forget driving down the street and suddenly becoming excited by the sight of randomly arranged shovels, brooms and other items being hauled in the open truck in front of me. RB

Her landscape painting is chosen for exhibit at the Kansas City Art Institute.

1955
Connie (now Chela) Diane Blitt is born. In her youth, she will share her mother's creativity as she develops her own vision for changing the world through writing and film.

1957
Blitt is commissioned by a pediatric office to paint her first mural. Her subject, animals on a boat dancing and playing instruments, reflects her fascination with music and water.

1958
"How often do you paint?" asks art historian Sidney Lawrence.
"Twice a week, when I have a baby-sitter," Blitt answers.
"If you really care about being an artist, you'll work everyday," Lawrence counsels.
Lawrence's belief that Blitt's ability is worthy of daily practice gives her the courage to decide:

I owe it to myself to become the best artist I can be, while always putting my family first. RB

"'That decision has always inspired me,' commented Blitt's daughter, Chela. 'It meant breaking from what was expected of her and pursuing art in a disciplined manner.'" RM

"The influence of Impressionism as Blitt moved in the direction of Abstraction is apparent in a wintery landscape in which barren trees, horses and geometric

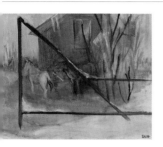

Red Barn
1958, oil on canvas, 24" x 30"

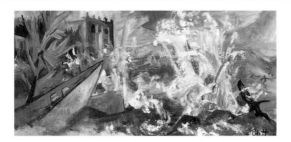

Bermuda
1958, oil on canvas, 16" x 34"

Kiddush
1958, oil on canvas,
32" x 20"

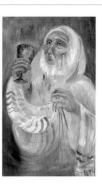

Blitt unintentionally
paints the man to
resemble her deceased
father.

137

lines of a gate in the foreground interact with the lines of a traditional barn in the background (fig. 160)." RM

1959
Blitt enters her first juried exhibit at the Kansas City Museum, Kansas City, Missouri, and wins an award for her oil painting.

Scott's Gallery and Frames, Kansas City, Missouri, displays Blitt's paintings in her first solo exhibit. Subsequent gallery exhibits are listed on page 163.

1960
The Blitt family takes their first trip to Aspen, Colorado, where the mountains and the classical music festival will have a major influence on Blitt's life and artistic development.

The Johnson County Mental Health Center requests a painting.

Fulfilling this request for a painting was the first of many opportunities I would have to give to others through my art. This is something I very much wanted to happen — in order to justify the privilege of spending my life creating. RB

1961-1964
She discovers the new acrylic paints, which dry fast and allow her to express herself with great freedom.

While painting at the park with artist friend Dorothy Mura, Blitt, frustrated, wants to quit — the only thing capturing her attention is a shadow on the water. Mura encourages her to continue, observing that if she feels like painting the shadow, then she must paint it.

I began listening to and following my inner voice.

A visiting professor at the Kansas City Art Institute suggested that before beginning a painting, I scribble one drawing after another, until I know exactly what is inspiring me to paint.

After that I began attacking the canvas with courage and eliminating all that seemed superfluous. RB

Blitt briefly experiments painting portraits of relatives and friends in 1964, but in most of her 1960s paintings of people, the features seem irrelevant to her.

Connie was angry — a rare happening. I was inspired by the curves of her face, pony tails and swim suit. I said 'Honey Hold It' and ran to get my paints (fig. 169). RB

Annual visits to Irwin's parents in Florida result in on-site paintings inspired by water. Then in the studio:

"Struck by the similarity of the sea gulls' flight and ocean breakers, Blitt painted Sea Gulls and Ocean with the bold, expressionistic brush stroke characteristic of her later work (fig. 220, cover of Interview)." RM

George Pickens, a visiting professor at the Kansas City Art Institute, advises Blitt to exhibit in New York. This

fig 163 fig 164 fig 165 fig 166

Maroon Bells *1960, acrylic on masonite, 24" x 30"*

Evening Shadow
1964, acrylic on canvas, 20" x 24"

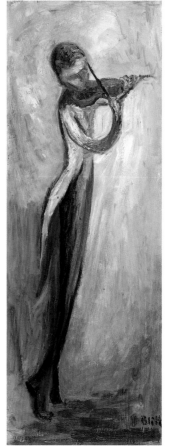

Aspen Violinist
1960, oil on masonite, 20" x 12"

Dance of the Shadows *1962, acrylic on canvas, 20" x 24"*

fig 170
Woman Feeding Sea Gulls *196
acrylic on canvas, 24" x 30"*

fig 173
Honeymooners *1965, acrylic on canvas, 24" x 30"*

138

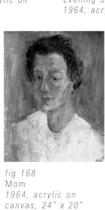

fig 167
Irwin and I
1962, acrylic on canvas, 42" x 12"

fig 168
Mom
1964, acrylic on canvas, 24" x 20"

fig 169
Honey Hold It
1965, acrylic on canvas, 24" x 20"

fig 171
Irwin
1964, acrylic on masonite, 24" x 20"

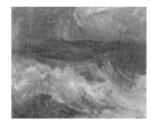

fig 172
Connie
1964, acrylic on canvas, 10" x 8"

fig 174
On the Beach
1968, acrylic on canvas, 24" x 30"

fig 176 fig 177

Poppies
1964, acrylic on canvas, 20" x 24"

Aspen Hillside
1964, acrylic on canvas, 24" x 30"

fig 180
Happy Rocks (Yearning to Return to Aspen)
1966, acrylic on canvas, 20" x 24"

fig 178
Those Years Have Come
1964, acrylic on canvas, 24" x 20"

fig 179
Contrast of Youth and Old Age
1965, acrylic on canvas, 30" x 24"

fig 181
Scott and His Cat
*1962, oil on masonite,
26" x 17"*

fig 175
Autumn Moon
1963, acrylic on canvas, 8" x 18"

fig 182
Connie Swinging
1965, acrylic on canvas, 30" x 40"

fig 183 fig 184 fig 185

Animals in Space?
1965, acrylic on masonite, 48" x 144"

I Never Saw Another Butterfly
1966, acrylic/tissue paper on masonite, 48" x 48"

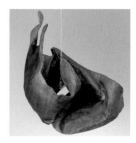

Crescendo
1966, acrylic on canvas, 14" x 12" x 12"

140

coincides with the beginning of Irwin's many business trips to New York. With the needed push from Pickens and the opportunity to join Irwin, Blitt begins preparing slides and a resume.

1965
Puzzled by the ease with which she paints, Blitt likens her experience to "spontaneous combustion." She becomes concerned that she is using nature and the human figure only as an excuse to paint.

"What she may not have fully recognized at that time was an emerging desire to be free of subject matter." RM

"Blitt's singular venture into abstract painting in the early 1960s is Animals in Space?, a 4- by 12-foot mural commissioned by Briarwood Elementary School, Prairie Village, Kansas. Inspired by Russia's Sputnik, the first orbiting satellite, and by colorful fish at Chicago's Shedd Aquarium, Blitt creates shapes similar to those that will appear in her drawings and sculpture a decade later (fig. 183)." RM

1966
I Never Saw Another Butterfly, in which a tissue paper butterfly is superimposed on children's numbered faces as they peer through barbed wire/hopscotch lines, is inspired by a book of drawings and poems by children at Terezin Concentration Camp (fig. 184).

"A theme in Rita Blitt's work concerns injustice. It is a rare Jew who has no family ties to the Holocaust.

Nearly every Jewish person alive today has learned something about this tragic slaughter, so that every Jew's view of the world is necessarily shaped by that knowledge." SR

Architect Chris Ramos asks Blitt to create sculpture for East Hills Mall, St. Joseph, Missouri, where she is installing Joys of Life, a tripartite mural. At first she declines his request, but then, remembering her recent yearning to create sculpture, she accepts the challenge.

Blitt begins experimenting with a variety of materials and finally selects a lightweight perforated sheet metal, which she cuts into abstract forms and shapes by hand. The resulting untitled work, suspended from the mall ceiling, resembles a flock of birds. Each component moves in response to ambient air currents.

Emerging from this experience wanting to continue working with three dimensional forms but unwilling to leave her paints, Blitt begins combining painting and sculpture into one art form. She cuts sheets of metal into abstract forms, covers them with canvas, shapes and suspends them from the ceiling. The dangling canvases twirl in space as she paints with bold, gestural brush strokes. She calls these new creations Canvas in Space and gives each a musical title such as Crescendo (fig. 185). Blitt follows with another suspended sculpture series inspired by the movement of the American Flag as it flies in wind.

In Memory of John F. Kennedy
1966, celastic, 30" x 5" x 8"

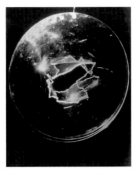

Orblitt I
*1968,
acrylic sheet,
23" x 23" x 10"*

Buddy's Beat
1972, acrylic sheet, 5" x 24" x 16"

"The senseless killing of President John F. Kennedy motivated Blitt to make art. To depict the horror of the assassination, she used violent methods. She gouged, stabbed and burned 'Ask not what your country can do for you but what you can do for your country' onto a celastic flag she had produced. This work is now in the collection of the John F. Kennedy Library in Boston (fig. 186)." SR

1967
Blitt's first sculpture exhibit, "Canvas in Space: Rita Blitt," follows a Thomas Hart Benton exhibit at Halls on the Country Club Plaza, Kansas City, Missouri.

A large Canvas in Space sculpture is installed in Leavenworth Plaza Shopping Center, Leavenworth, Kansas.

1968
After scheduling her first New York gallery exhibition for the spring of 1969 to show her Canvas in Space Series, Blitt begins to worry that the paint on the sculptures' surfaces should be blended instead of painted with the gestural strokes she so enjoys making. Also upset with the lack of perfection of the glued and sewn canvas edges, she decides to find a new material for the sculptures or cancel the exhibit.

Blitt happens upon a book about acrylic. She later writes in her manuscript *Life's Not Always Chocolate*:

The period that followed was filled with exhausting research and experimentation. Acrylic sheet, the

answer to my problems, was abundant with new ones. I loved it for gracefully responding to my touch when heated and for performing magic with light and shadow, but despised it for cracking and becoming scratched as I worked. Acrylic demanded skills entirely foreign to me and a precision contrary to my nature. RB

"A body of acrylic sculptures, most of them suspended from the ceiling, are the result of this experimentation. She named her exhibit Orblitts, uniting the shape of some of the sculptures and the path of their movement in space with her surname." RM

I'll never forget walking into the room where my suspended sculptures hung very still — and seeing them move in response to our presence. RB

"In making Orblitt I, subtitled Beautiful Ugliness, Blitt ordered two identical discs of clear acrylic sheet nearly two feet in diameter and heated them in an oven to make them pliable. As she shaped the first disc, it began to cool and she inadvertently exceeded the stress limits of the acrylic, tearing open the center of the disc. Surprised by the beauty of the torn edge, she returned the cooled disc to the oven to further soften the material so that she could continue tearing it. She repeated this newly discovered technique with the second disc. To complete the sculpture, Blitt suspended the discs vertically parallel to one another, the shaped edges turning outward from the center (fig. 187).

141

fig 189 fig 190 fig 191

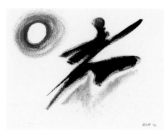

Dancing Fir Tree *1972,*
watercolor on paper, 12" x 16"

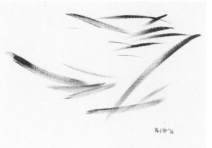

Ode to Matisse
1976,
acrylic
on canvas,
24" x 30"

Aspen
Joy
1976, acrylic
on canvas,
24" x 30"

142

"This sculpture is beautiful with light reflecting from its surface as it is gently moved by air currents. In contrast, due to the jagged holes in its center, it may be understood as threatening — possibly suggesting the sociocultural conflicts of the 1960s: the Vietnam War, student protests everywhere, and the assassinations of President John Kennedy, his brother Robert and civil rights leader Dr. Martin Luther King." RM

1969
Blitt begins writing her unpublished manuscript *Life's Not Always Chocolate* while packing her New York exhibit Orblitts. Instead of recording her joys as originally intended, she soon begins recounting her frustrations:

Struck with inspiration, the gallery director grabbed my red velvet sculpture bags full of white packing foam, crawled out the second floor window onto the roof of the restaurant below and, murmuring 'It's so surreal! It's so surreal!' dumped my 'plastic snow' on the real snow… The next morning, Irwin's departure to pick up breakfast, leaving Connie and me alone in the gallery, was followed by a pounding on the door. A tremendous man appeared in the doorway. He looked angry. Not only the landlord of the building, but also the owner of the downstairs restaurant, he said the white bits were being sucked through the kitchen exhaust fan and into his frying grease. Two batches had been thrown out already. He threatened to dispossess the gallery. RB

1970-1974
Although the first year following the New York exhibit is mostly devoted to writing *Life's Not Always Chocolate,* during the early 1970s, Blitt fulfills several sculpture commissions: two for Indian Springs Shopping Center, Kansas City, Kansas; two for Jefferson Square Mall, Joliet, Illinois; one for Golden Ring Mall, Baltimore, Maryland; and one for City Hall, Kansas City, Kansas.

Leftover colored acrylic materials from the commissions become small playful sculptures. Buddy's Beat is created after Blitt sees Buddy Rich playing the drums (fig. 188).

Inspired by a Picasso exhibit at The Museum of Modern Art, New York, New York, Blitt has a brief but intense period making found object sculpture. Creating Dance of Destiny, and then three days later seeing a French print from 1844 that is reminiscent of her new wild creation, is one of Blitt's most memorable experiences (figs. 222, 223).

Blitt is inspired by the works of Miro, Klee, Picasso, Matisse and Calder during travels to France.

1975-1976
After seeing 14-year-old David Parsons dance, Blitt instinctively feels that he has a special talent and goes backstage to compliment David and his mom. This begins a long history with David and later The Parsons Dance Company.

fig 192 fig 193 fig 194

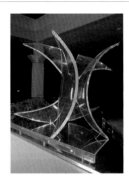

Stablitt XXXIII
1975,
acrylic sheet,
62" x 72" x 80"

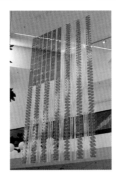

Flag: 1976
1975,
acrylic sheet,
20 feet x 126" x 3"

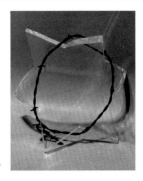

Struggle For
Survival
1976, acrylic
sheet/barbed wire,
10" x 9" x 7"

143

"In 1975, news accounts accusing the CIA of murders and reports of the United Nations' passage of a resolution damaging the reputation of Israel seemed to signal a world gone mad. Blitt's response was to tie her lyrical acrylic sculptures with rope. This reaction led to a work titled Struggle for Survival, in which she wrapped a Star of David, symbol of the State of Israel and of the Jewish people, in barbed wire. A viewer has the impulse to free the sculpture, to let the art go free (fig. 194)." SR

Struggle for Survival is now in the collection of the Skirball Cultural Center, Los Angeles, California.

Blitt creates four sculptures for installation at Oak Park Mall, Overland Park, Kansas.

Beginning with a 6- by 6-foot by 2-inch piece of acrylic, the largest she has ever manipulated, Blitt heats and shapes Stablitt XXXIII (fig. 192). Utilizing acrylic rods, she creates the 36-foot Aquablitt VII.

For Flag: 1976, an official bicentennial project of the state of Kansas, Blitt returns to flag imagery with a hanging sculpture measuring 20 by 10 1/2 feet made of 1,748 pieces of acrylic (fig. 193). This sculpture is the inspiration for a seven-minute film, *Flag: 1976,* contrasting the sawing, cutting, heating and shaping of Blitt's acrylic flag with the sewing of the original American Flag by Betsy Ross.

"Lunarblitt XVI is a reductive work Blitt calls her 'yellow ball' sculpture. This elegant and playful work

consists of three components: a polished stainless steel post supporting a concave stainless steel arc with a brushed bottom and highly polished top, which, at one high end, supports a bright yellow aluminum sphere or moon. The sphere appears to be about to roll down and then up to the opposite end of the arc, looking like an enormous child's toy in its simplicity, exuberance and deceptive precariousness (fig. 10).

"Blitt recognizes her 'yellow ball' sculpture as a pivotal work not only because it increased her understanding of the origins and evolution of her vision, but also because it has affected everything she has created thereafter. RM

When I first saw my "yellow ball" sculpture... it felt more like me than anything I had ever created. It came from a little doodle! I realized then that the doodles I had been discarding all my life were the essence of me. RB

"Following this insight, Blitt allowed herself 'the luxury' of putting her doodles — spontaneous lines — on clean, quality paper." RM

Quickly marking one page after another, I repeated the same gesture over and over, simplifying until it felt finished. One series ended with a straight line. Another seemed to have to end with a blank piece of paper. All of this was unself-conscious. I was in awe of what began coming from my hand." RB

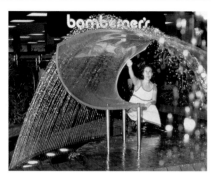

Aquablitt
1977,
acrylic sheet,
60" x 120" x 120"

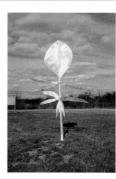

My Friend
1978,
stainless steel,
82" x 58" x .5"

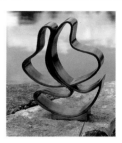

Destiny
1993, bronze, 14" x 12" x 3"
From a 1978 drawing

144

1977

Perhaps inspired by music in the background, Blitt takes a conté crayon in each hand and begins drawing with two hands at once.

> At first shocked... and somewhat embarrassed... I ultimately knew I had to continue working with both hands in order to feel honest, to feel whole.
>
> I later wrote, 'I feel like I'm dancing on paper.' [RB]

Blitt's drawings and paintings from 1977 on are mostly created with two hands at once excluding those in the Black Box and Iceland Series.

"Simultaneous imagery, an activity also practiced by Cubists and Dadaists, in which both hands create at once, eliminates the conscious side of art production. Like the automatic drawing and painting of Dada and Surrealist artists, Blitt uses this reflex-like technique for tapping her unconscious," wrote curator Donna Stein.

> I believe spontaneous drawing with one hand and two at once led me to become a more centered human being and that drawing in this manner can be practiced by everyone. [RB]

"Artist Elizabeth Layton, a spectator to Blitt's process, wrote, 'It's fascinating to see her make these drawings with two hands working at the same time, in a real rhythm...so dancing and full of joy...,'" recalled Hannah

Hanani in her article "Georgia O'Keefe and Other Women Artists." Hanani goes on to describe Blitt's process as "catching the soul during its off guard moments."

The Harkness Foundation of Dance, New York, New York, hosts a Blitt exhibit of drawings and sculpture.

Blitt creates three sculptures for Rockaway Townsquare, Rockaway, New Jersey: Aquablitt (fig. 195), Stablitt 55 (fig. 44) and American Flag, a 20-foot stainless steel and brass flag that is suspended from the ceiling. After speaking with students in six neighboring schools, Blitt invites them to engrave their names on the flag's stars. A plaque near the sculpture diagrams the location of each child's star. One star is buried in a time capsule.

1978

Two more Blitt sculptures are installed at Rockaway Townsquare, Rockaway, New Jersey. A construction worker names the abstract steel sculpture Nessie (fig. 199) after the prehistoric monster that is reputed to inhabit the waters of Scotland's Loch Ness.

The excitement and frustrations of the installation inspire Blitt to begin writing a children's book, *Nessie the Sculpture*, published in 1982.

"Blitt's text and drawings tell the story of public sculptures, explaining that they are the realization of an artist's vision and require the collaboration of

fig 198 fig 199

Nessie
1978, pencil on paper

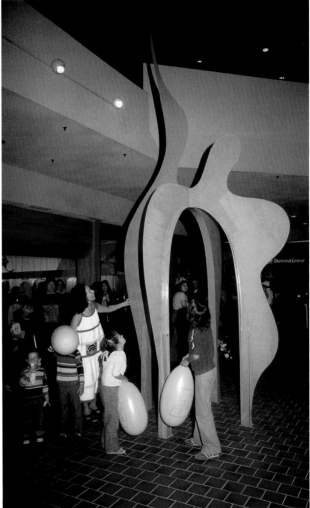

145

crafts-people, technicians, entrepreneurs and skilled workers. The cover features an easy-to-assemble, two-part, punch-out image of Nessie designed so that children can erect a sculpture themselves." RM

Yearning to combine the arts, particularly music with visual art, Blitt collaborates with percussionist/composer Dr. Michael Udow to attach harmonically toned metal rods to an 82-inch stainless steel sculpture. My Friend becomes a percussive instrument when the metal bars are plucked and set in motion (fig. 196).

Hickory Point Mall, Forsyth, Illinois, commissions three sculptures.

Works related to the American Flag (sculpture, drawings, torn paper collages and a painting) are displayed in a solo exhibit at Tumbling Waters Museum of Flags in Montgomery, Alabama.

1979
David Knaus, director of Tall Grass Gallery, Overland Park, Kansas, begins a continuing dialogue with Blitt about her work and assists with exhibits.

St. Louis University, St. Louis, Missouri, exhibits Blitt's flag works and acquires a print of One Plus One Equals One for the university's collection.

Johnson County Community College, Overland Park, Kansas, hosts a solo Blitt exhibit.

Nessie
1978, painted steel, 16 feet x 96" x 96"

Yellow Dot
*1986, water-
color on paper,
16" x 20"*

*I added the yellow dot years later. Is this
the sun that keeps reappearing in my work?* RB

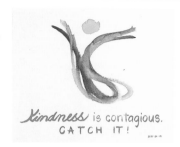

Kindness is Contagious. Catch It!
1986, poster, 16" x 20"

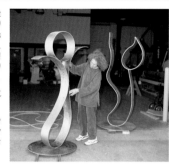

Spirit's Delight
(background)
Kindness is
Contagious.
Catch It!
*(foreground)
both 1998,
stainless steel,
72" x 32" x 8"*

*Sculpture
inspired by
earlier drawings*

146

1980

Blitt creates four sculptures for installation at Bannister
Mall, Kansas City, Missouri:

"Together, fabricated from laminated oak, effectively
communicates ascension (fig. 55). Dancing, a monu-
mental 26-foot steel figure, suggests seduction and joy
(fig. 39). Like many of Blitt's metal and wood sculp-
tures, Dancing has also been fabricated in bronze
(fig. 38). From the branches of the 11-foot steel
sculpture Wishing Tree hang 4-inch mirrored acrylic
discs, on which high school seniors inscribed their
names while making a silent wish. Twenty-six-foot
Trio is fabricated in steel and painted white (fig. 60)." RM

Because Blitt is so fulfilled by drawing spontaneously, she
encourages others to also let their hands "dance on
paper." Blitt's lecture at the International Council of
Shopping Centers Convention leads to the creation of
the video *dancing hands: Visual Arts of Rita Blitt*, 1984.
She collaborates with Pentacle Productions on this 25-
minute film, now distributed as *Creating Drawings and
Sculpture with Rita Blitt*, chronicling 20 years of her work.

Philip Yenawine, former Director of Education at
The Museum of Modern Art, New York writes: "With
quiet control, *dancing hands* unfolds the development
of Blitt's art, the camera gently playing with her delight
in materials and forms in space. The film provides
extraordinary insight into an artist's processes."

In workshops, after viewing the film, participants
create drawings while classical music plays in the
background. I ask them to follow three basic rules:
1) Pretend you are the only person in the room.
2) Work quickly, letting lines flow, drawing with one
or two hands at once.
3) Let the lines come from deep within you, feeling
each line while you work. RB

Blitt creates a wall sculpture for The Parsons Dance
Company performance at Dance Theater Workshop
in New York City.

"Although sculpture dominates the 1970s and 1980s
for Blitt, the practice of drawing continues almost daily
as a source of joy and ultimately a fountainhead for
sculpture patterns. Blitt realizes that since 1976, she
has been so engrossed in pure black line that she has
stopped using the color she loves." RM

In response to this realization, she begins lighthearted
experimentation adding color with pastels to her black
lines.

1981

The pastels soon become more serious as Blitt advances
into her Oval Series, which, as curator Donna Stein
commented, "call forth the imagery of Mark Rothko
(figs. 72-79)."

"Placing both hands at the bottom of a 30- by 22-inch
sheet of paper, she moved her pencils to opposite sides
of the sheet, allowing her hands to meet again at the

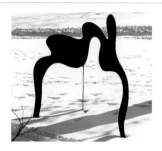

Reality ? *1990,*
corten steel, 60" x 72" x 43"

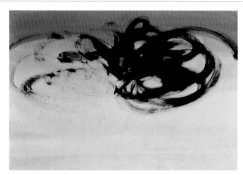

Seeking Truth
1989,
ink on paper,
22" x 30"

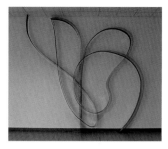

Grace
1990, stainless steel, 19 x 18 feet

147

top center forming a simple slightly pointed oval to which she added color. The oval seemed to temporarily satisfy the artist's search and consumed her for several years." RM

To my own amazement, I said, 'I'm finished. This is what I've been struggling for... all these years. Why have I been dancing all over the page?' RB

"Rita is a mystical artist in a totally natural way. The energy of this essence simply flows through her without effort. In watching her work, one experiences a profound awareness that Rita opens herself to a spiritual flow and it expresses itself through her... in movement, in color and in form," observed Doctor Marj Britt, Minister of the Unity Church of Tustin, California.

1982
Rockaway Office Park, Rockaway, New Jersey installs Blitt's 16-foot steel sculpture, Tatsu, 12 drawings and a felt wall hanging made from a Blitt pastel titled Green Eyes (fig. 63).

1983
Two sculptures are installed at Loehmann's Plaza, Orlando, Florida. One sculpture is installed at Indian Springs Shopping Center, Kansas City, Kansas.

1984
At a concert, Blitt is so deeply moved by the music of Mexican avant-garde composer Mario Lavista, and the words of the ancient Chinese poet Li Po (701-763 AD) that Lavista uses to introduce his music, that she goes backstage to propose a collaboration.

This encounter results in Lavista's music being added to the design of Orblitt: 1984, an inverted womb-like form that rests on a three-foot-tall brass cylinder containing speakers. Electronic sensors and components are hidden nearby. Viewers unknowingly turn on Lavista's music as they approach the sculpture (fig. 80). A later experimental sculpture, Throne of Serenity, is a chair containing an audio cassette player that is activated when the seat is occupied (fig. 81).

In addtion to Orblitt: 1984, a 60-foot steel sculpture titled One (fig. 35), several pastels and an oil painting, are installed at The Renaissance I, an office complex in Overland Park, Kansas. Two years later, a 7-foot bronze and a brass wall sculpture are created for The Renaissance II, also in Overland Park, Kansas.

Blitt installs a sculpture at the Embassy Suites Hotel, Overland Park, Kansas, and two stainless steel sculptures in Loehmann's Plaza, Miami, Florida.

1985
Blitt fabricates three steel sculptures that play music when approached: Fantasy (along with a non-musical steel sculpture, Infinity), at Loehmann's Plaza, St. Louis, Missouri; Karma, at Loehmann's Plaza, Babylon, New York, later moved to a Long Island public golf course; and Fiesta, at Loehmann's Plaza, Lake Grove, New York. Fiesta has since been acquired by Dr. Betty Barker Bashaw for Baker University, Baldwin, Kansas, in memory of Dr. Othello (Dale) Smith.

fig 206　　　　　　　　fig 207　　　　　　　　　fig 208

Emerging Energy
*1986, acrylic gel/paste on
masonite, 36" x 40"*

Beyond
*1990, acrylic on
masonite, 24" x 24"*

In Fear of War　*1990,
triptych, acrylic on masonite, 30" x 66"*

1986

Desiring to create works for the wall but not wanting to leave sculpture, Blitt forgoes the paintbrush for her hands, applying thick acrylic gel and paste on masonite (fig. 206). A painting from this series becomes part of the collection at the Albrecht-Kemper Museum of Art, St.Joseph, Missouri.

Blitt's friend, activist Beth Smith, challenges Blitt to create something that can communicate universally and be sent all over the world to make it a better place.

> I was overwhelmed by the significance of this request that seemed so impossible to fulfill. Years later, when the words 'Kindness is Contagious. Catch It!' came to me, I was very excited. I envisioned a program for children and adults alike. [RB]

Blitt's words inspire an international kindness program sponsored by the Kansas City-based Stop Violence Coalition, which touches the lives of millions. The "Kindness Poster," incorporating a Blitt watercolor with her phrase, is seen around the world and a Blitt sculpture is given annually to the three kindest Kansas Citians chosen from thousands of letters of nomination submitted by local school children (fig. 201).

Blitt installs sculptures at Loehmann's Plaza, Davies, Florida, and Town Pavilion, Kansas City, Missouri. A sculpture that plays music recorded by Yehuda Hanani is installed at B'nai Jehudah Temple, Kansas City, Missouri,

shortly after Blitt meets the Hanani family at the Aspen Music Festival.

1987

"Among Blitt's many monumental sculptures, Inspiration may be the best known. Masterfully sited by architect Steve Abend adjacent to the Hillcrest Bank on the outskirts of Kansas City, this steel sculpture resembles a full-bodied figure with a distant kinship to the Venus of Willendorf (ca. 25,000-20,000 B.C.E.). Viewed laterally, the sculpture resembles an austere, vertical totem that retains power and majesty (fig. 58)." [RM]

A small wood version of Inspiration wins a national competition sponsored by the Midwest Women's Center in Chicago. Reproductions of the sculpture are awarded to 12 outstanding women in Chicago.

The Chloé Series of 40 paintings on paper is created in honor of the birth of Blitt's grandniece, Chloé White.

1988

In honor of Irwin's leadership in the establishment of the Jewish Community Campus in Overland Park, Kansas, Blitt creates a brass wall sculpture.

1989

Responding to a new sense of freedom provided by enlarged studio space, Blitt allows her lines to fly off and back onto the paper, leaving connecting lines of paint on the table where she works. Challenged to make sculpture from these drawings, even though

fig 209

fig 210

fig 211

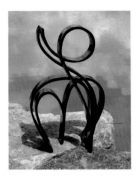

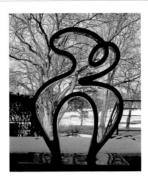

Dignity
1996, wood,
60" x 41" x 5"

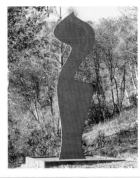

Happy Day Mom
1993, wood,
18" x 14" x 7"
- edition 1/3

Rhapsody
1998,
corten steel,
12 feet x 30" x 1"

there is not an obvious form to extract, Blitt cuts along the curving lines dividing the 30- by 22-inch paper into two to four shapes that can stand alone or be reunited into a rectangle. From the shapes, Blitt then creates her Black Box Series (figs. 87-97, 212).

After a gallery vetoes Blitt's desire to allow visitors to participate in the creative process by rearranging the parts of her Black Box sculpture, Blitt decides to weld the parts of the rectangle together in various relationships, often repeating some shapes and eliminating others.

"Blitt's Black Box Series and Variations epitomize her ability to successfully play with line and form, unity and variety, geometrical stasis and lyrical movement." [RM]

A solo exhibit of Blitt's gestural drawings, paintings and sculpture is displayed at The Goldman Gallery in Haifa, Israel. The exhibit then moves to Beit Shmuel Centre, Jerusalem, Israel.

Two stainless steel wall sculptures are installed at Mission Center Mall, Mission, Kansas: Jubilee in 1989 and Grace one year later.

1990
Blitt finds new strength in her lines when suddenly her eyes close as she paints. She refers to the deeply felt works produced without seeing as her Chi Paintings (figs. 99-108).

With my eyes closed I am able to express what I never would have otherwise expressed. [RB]

"With a paint brush in each hand, she releases powerful thrusts of energy reminiscent of the mystery and power of ocean waves as they strike the rocks on the beach and then dissipate into the air," wrote David Knaus.

"The United States and the United Nations issued an ultimatum to Iraq with a specific deadline. Americans watched the clock tick toward war. Blitt's triptych, In Fear of War, part of her Gulf War Series, conveys her anguish at the thought of another confrontation (fig. 208)." [SR]

1991
Blitt has a solo exhibit of sculpture and drawings at the National Museum Art Gallery, Singapore, titled, "Rita Blitt, Reaching Out From Within." In response, *The Straits Times* newspaper critic T.K. Sabapathy writes:

"If Paul Klee dreamt of taking a line for a walk, then Rita Blitt realizes that dream palpably and in the most exhilarating way. The line, however, is not Blitt's only interest. In a number of works collectively referred to as the Black Box Series, she immerses herself in pure sculptural preoccupations, namely spatial relationships. Separate but Together exemplifies both the fragility and the need for continuing relationships (fig. 96). One leaves this exhibition with satisfaction in having entered a world in which ideas and means have been integrated in expressions which are illuminating and elegant."

149

fig 212 fig 213

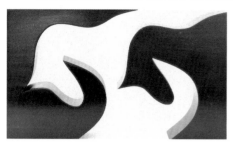

Seth's Black Box
1993, wood,
11" x 12.5" x 3"

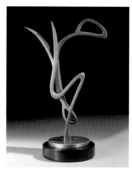

Jazz
2000, bronze,
15" x 9" x 5.5"
- edition 1/11

Inspired by a 1994
drawing

150

Fleeting Passion or True Love? is acquired by the National Museum Art Gallery, Singapore (fig. 97).

1992
The Aspen Institute, Aspen, Colorado, hosts a solo exhibit, "Rita Blitt: Outdoor Sculpture and Drawings." Separate But Together and I Do become part of the institute's permanent collection (figs. 96, 49).

"Blitt's recent art, minimal as it may be, is a swivel, taking you up and around — a dance, elating and enchanting. The rhythm of her brush strokes seems almost traditional Japanese, but it is not conventional — it is free and emotional." BN

1993
On a voyage to Iceland, as 17-foot waves rock the ship, Blitt is energized by the power and motion of the surging water. She turns her paper to a horizontal position and lets the turbulence help guide her hand, thus creating the source for her Iceland sculptures (fig. 111-118).

A 96-inch wood sculpture, Happy Day Mom, is installed at Oak Park Mall, Overland Park, Kansas, (small version, fig. 209) and a 72-inch bronze sculpture, Dancing, is installed at Sherman Oaks Medical Center, Sherman Oaks, California.

"Israel and the PLO took their first steps toward peace through the intervention and diplomatic leadership of Norway. Hope was in the air, and Rita Blitt wanted to

express gratitude and relief in her own way. She produced a small wood version of Inspiration as a gift to the government of Norway. This gift, given through the United Nations, inspired her to make a print in honor of Norway for all 183 members of the United Nations as a reminder to reach out and aid others locked in conflict." SR

1994
The city of Leawood, Kansas, gives a small bronze version of Inspiration to I-Lan, its sister city in Taiwan.

Iceland Series is featured in a solo exhibit, "Rough Seas," at the Krasl Art Center, St. Joseph, Michigan.

"Rita Blitt in Retrospect," is featured at The Kennedy Museum of Art, Ohio University, Athens, Ohio.

The Kansas City Parks & Recreation Department asks Blitt to create a 12-foot stainless steel Spirit's Delight, first installed in Loose Park, then relocated to The Country Club Plaza (fig. 42).

Blitt creates a series of drawings in response to a rehearsal at The Parsons Dance Company. A drawing titled Jazz becomes a wood sculpture and later is fabricated in bronze (fig. 213).

A solo exhibit of selected works featuring Jazz opens in conjunction with a performance by The Parsons Dance Company and the Billy Taylor Trio at Krannert Center for the Performing Arts, University of Illinois at

fig 214

fig 215

St. Joseph Ballet
*diptych, 1995,
acrylic on muslin,
96" x 16 feet*

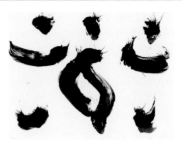

Dancing
1996, acrylic on paper, 22" x 30"

151

Urbana-Champaign, and later moves to the I Space Gallery, sponsored by the University of Illinois at Chicago.

"From her nonstop practice of drawing since 1977 with conté crayons, ink and paint, Blitt develops an especially acute sense of rhythm, space and intuitive composition. Her dancing lines lead to exciting artistic collaborations." RM

1995
In collaboration with the St. Joseph Ballet of Santa Ana, California, a company dedicated to making a difference in the lives of inner city youth, Blitt creates four large-scale paintings and a plexiglass suspended sculpture for the season's performances at the Irvine Campus of the University of California (fig. 214).

These paintings, up to eight feet tall and 20 feet wide, allowed me to discover my love for painting life-size and larger. RB

Having filled numerous books, drawing in response to music at concerts throughout the 1990s (fig. 123), Blitt continues to intensify and expand her musical experiences by creating large oil paintings in response to music (figs. 119-122).

When painting to music, I don't add a stroke without the music guiding me. RB

She sometimes turns off the music and paints to her own Inner Music (fig. 124). While creating these

paintings, Blitt discovers that in addition to drawing lines with both hands at once, due to the natural harmony of body movements, she can successfully apply color in the same manner.

Encouraging others to draw to music, Blitt conducts an audience in responding to music with crayons and paper at the New Ear Concert, St. Mary's Church, Kansas City, Missouri.

Upon request by professional speaker and author Barbara Glanz, Blitt completes drawings illustrating the spirit of each chapter for Glanz's book, *CARE Packages for the Workplace*, published by McGraw Hill.

"Rita always seems to capture the essence of the experience. Intensity balanced by joy, depth balanced with spontaneity, she brings her audience to the heart, the core of the feeling," comments Glanz.

In celebration of the memory of Dr. Othello (Dale) Smith, a solo exhibit of Blitt's work opens at Baker University, Baldwin, Kansas.

Before traveling to California to help prepare for the birth of her granddaughter, Blitt paints a 7- by 18-foot canvas that she titles Messages to an Unborn Child (fig. 216a, 216b).

1996
A painted steel sculpture titled Skybird, is installed in the Taliaferro Sculpture Garden, Prairie Village, Kansas.

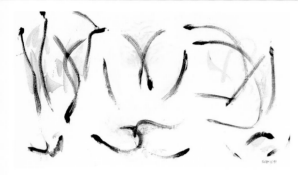

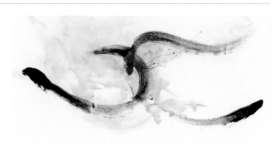

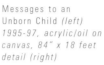

Messages to an
Unborn Child *(left)*
*1995-97, acrylic/oil on
canvas, 84" x 18 feet
detail (right)*

152

The Georgia Institute of Technology, together with The Parsons Dance Company, The Atlanta Ballet and Rita Blitt, uses cutting-edge technology to present an art-meets-science performance.

"Infused with euphoria over the birth of Dorianna, Blitt must have been performing dances of joy as she painted black lines on huge canvases up to 7 by 12 feet. The heroic scale of these canvases projects the universality of the personal and unique dramas that they represent (figs. 140,144,146,147,148)." RM

1997
Blitt returns to her Dorianna Series, created a year earlier after the birth of her granddaughter. Despite feeling intimidated by the success of the black lines in their compositional rightness and fearful of ruining the paintings as they are, she feels compelled to add color.

"While her lyrical black gestures convey a sense of muscular energy, her pastel washes of thinned oils proclaim a feeling of rapture." RM

1998
A Hong Kong art consultant commissions Blitt to create two sculptures for the Hilton Tokyo Bay, Bay Lounge, Shiba, Japan: Kindness is Contagious. Catch It! and Spirit's Delight, each fabricated 72 inches tall in stainless steel (fig. 202).

1999
Blitt creates a body of large paintings, much of the time responding to Beethoven (figs. 135-139).

After having reacted to world events by tying her plexiglass sculptures with rope in 1976 and even earlier using rope as an element in her found-object sculptures, Blitt now uses rope's fluid qualities to emulate her lines for wall sculpture (fig. 217).

Longing to create affordable, small works that can exist in nature, Blitt fabricates wood sculptures mounted on steel pipes for outdoor installation (fig. 218).

2000
Eighteen-foot steel Delight is installed in the Compass Corporate Centre, Overland Park, Kansas (fig. 219).

"Her work has been called 'a link between nature, humans and architecture,'" wrote Catherine Rips Gerry.

Following the installation of a large group of paintings on paper, Blitt will become the first Kansas City-based artist to have a permanent collection on campus at the University of Missouri-Kansas City. In addition, plans are being finalized for the Living Room: A Room to Celebrate Life in the new Conservatory of Music, also on the University of Missouri Kansas City campus, which will house an additional collection of Blitt drawings, paintings and sculpture.

fig 217

fig 218

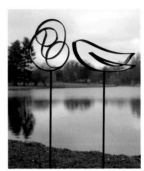

Bountiful Love
*1999,
wood/steel pipe
72" x 24" x 3"*

Joie d' Vivre
*1999, rope wall
sculpture, 33" x 18"
- edition 1/3*

Flowing Energy
*1999,
wood/steel pipe
63" x 36" x 3"*

Blitt begins the fabrication of her Choreography Series, in which six gestural ribbons of bronze can be infinitely recombined and welded together in dancing positions.

In the fall of 2000, Blitt will permanently install a 9-foot steel Inspiration in front of the new Women's Studies Research Center at Brandeis University. The opening of this building will be celebrated with the first showing of "Rita Blitt: The Passionate Gesture," a traveling exhibit.

"Connecting to life in its fullest sense forever refreshes the artistic vision of Rita Blitt. Throughout her career as an artist, whether painting, drawing or sculpting, she has created works of art that make statements of extraordinary economy and sublime beauty. They emphatically ratify and illustrate the truth of Ludwig Mies van der Rohe's reductivist aphorism, 'Less is more.' They are 'less' in being composed, for the most part, of a very few intense gestural marks. They are 'more' for concentrating the artist's intelligence, feeling, energy and memory into minimalist statements, keys for viewers to use in understanding the wonders of their own experiences." RM

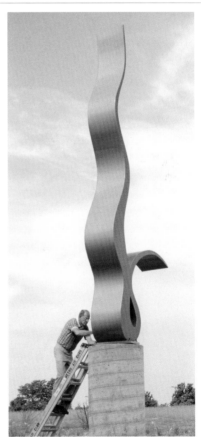

fig 219
Delight
*2000, steel,
18 feet x
84" x 22"
Dave Roth,
fabricator*

*From a
1987 drawing*

153

fig 220
Detail of Sea Gulls and Ocean I
1964, acrylic on canvas,
48" x 60"

INTERVIEW
A conversation between writer/filmmaker David Knaus and Rita Blitt

DK: *When did you first have some awareness of the creative process?*

RB: My fifth grade teacher introduced me to the magic word "create." I still get excited when I hear it!

DK: *How did you start fabricating sculpture as public art?*

RB: In the early 60s, when the enclosed mall was still a new idea, my husband began developing one. He and the architect, Chris Ramos, asked me to create art for the project.

DK: *Are you essentially self-taught? Did you formally study sculpture or sculptural techniques?*

RB: I was trained primarily as a painter, so making sculpture was an exciting new challenge. First I experimented with every material I could manipulate with my own hands — papier mâché, celastic, light weight metal and acrylics. In the 70s, when I began making monumental sculptures from my spontaneous drawings, I needed the help of a structural engineer and fabricators with sophisticated machinery. Together we figured out ways to make my lines exist in space.

DK: *What was the most challenging sculpture you ever made?*

RB: Probably Stablitt 55, my first monumental sculpture, created in 1977 for Rockaway Town Square, Rockaway, New Jersey (fig. 44). Little did I dream that when my drawing was enlarged to 26 feet, I would be confronted with about 20 almost indistinguishable pieces of paper that needed to be put together like a huge jigsaw puzzle to become the sculpture pattern. After fabrication in steel, Stablitt 55 was delivered in seven parts. When the construction men were dangling the second part in the air, they hollered down from the scaffold: "It doesn't fit." I yelled back, "My fabricator in Kansas City

said it's idiot proof." And they fired back to me, "Next time, bring the idiots. It doesn't fit."

DK: *And you got it to fit?*

RB: Yes. We concluded a piece was missing. It was found in Kansas City and immediately air-freighted just in time for the sculpture to be welded together for the center's grand opening. Each sculpture has its own story. I have learned: The bigger the project, the bigger the frustrations.

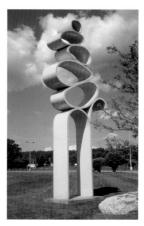

fig 44 (also on page 29)
Stablitt 55

DK: *Is there a pivotal sculpture?*

RB: Yes. My 6-foot 1975 "yellow ball" sculpture (Lunarblitt XVI, fig. 10). Seeing this sculpture, that came from my little doodle, led to the past 25 years of gestural drawings, paintings and sculptures.

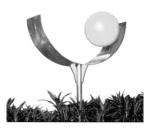

fig 10 (also on page 15)
Lunarblitt XVI

DK: *Have you ever made a sculpture without one of the spontaneous drawings? In other words, seen it in your head and then created a sculpture based on that?*

RB: Yes. That's how I created everything prior to the yellow ball sculpture.

DK: *Do you have a preference for a particular material? Do you think your work lends itself to one material or another?*

RB: I prefer steel for monumental sculpture. I like stainless steel because it doesn't require a protective finish and I can etch the surface. I like corten steel because the rust color changes as the surface ages. It seems very natural and earthy. If I want to paint the surface, I use carbon steel. Bronze is costly but I like to use it for small pieces. For maquettes and small wall sculptures, I usually use wood. And then, some drawings lend themselves to being fabricated from thick acrylic.

KN: *Material-wise, I think the work you've made in acrylic is among the most interesting. I remember your commenting that the orb — the acrylic piece with the hole torn in the center (*Orblitt I*, fig. 187) — was the most powerful sculpture you had done and might ever do. Over the years, it seems to me you've shown a preference for acrylic over wood or metal. When I was in your studio last month, I made a note after I had left that two or three times, when you were looking at things, you veered away and commented on acrylic pieces that were there. Do you relate to that material because of its transparency? I think the rectangular acrylic with the slit corner, shaped like the crest of a wave, is one of your most important pieces (fig. 221).*

fig 187 (also on page 141)
Orblitt I

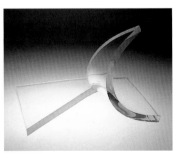

fig 221
Splash of Light
1976, acrylic sheet, 16" x 24" x 18"

RB: I didn't realize I show partiality to acrylic. I have always been fascinated by its reflective qualities and transparency. Actually, in the early 70s, after only a few years heating and shaping 1/8-inch and 1/4-inch acrylic, I felt finished with the material. Then a shopping center commission led me to the discovery of 2- to 6-inch-thick acrylic, which I occasionally still use.

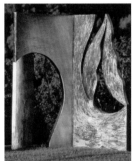

DK: *The big stainless steel piece in Aspen,* Seeking Truth, *where you etched the surface, is absolutely one of the best pieces you've ever made. How do you etch the surface of stainless steel (fig. 95)?*

RB: With an electric sander I mark the surface, as if I'm drawing on paper.

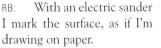

fig 95 (also on page 83)
Seeking Truth

DK: *What was the first work of art that you remember responding to?*

RB: I recall as a young girl admiring Thomas Hart Benton's painting *Achelous and Hercules*, now in the collection of the National Museum of American Art, Washington D.C.

DK: *Which artists do you particularly admire?*

RB: My heroes are Picasso and Matisse.

DK: *Are there any artists whose spiritual qualities affect you?*

RB: Yes. I'm especially drawn to the color and serenity of Rothko's work and the magical line in Charles Burchfield's paintings.

DK: *How did your spiritual quest begin?*

RB: In 1968. At the opening of my first New York exhibit, the New York correspondent for the *Kansas City Star* took me aside and asked about my spiritual feelings. I murmured some thoughts of God, wondering why he was asking that question.

Soon after that, I read M.C. Richard's *Centering*, which caused me to begin thinking about my inner self.

Then, in 1973, I was shocked when the *New York Times* book review section reproduced a French drawing from 1844 (fig. 223) that looked so much like my wild found-object sculpture, Dance of Destiny (fig. 222) that I had just concocted with a ladder, a broom from Thailand, a stainless steel ball meant to hang in a pitcher to keep martinis cold, strips of 1/8-inch acrylic sheet and canvas. After that, I began noticing the incredible synchronicities in my life.

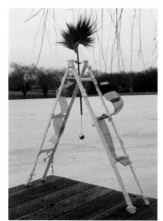
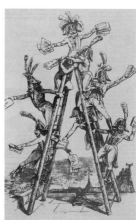

fig 222
Dance of Destiny
1973, 66" x 56" x 18"

fig 223
"La Concurrence" 1844
Pictured in the "New York Times," 1973

DK: *You have spoken about the prolificness of the drawings, how many you churned out and that it was bewildering to you. In retrospect now, is it any clearer where your drawings come from?*

RB: No, not really. I was amazed at the spontaneous drawings that began pouring out from my hand in 1976 — and then from both hands at once beginning in 1977. I felt each line coming from within me. If I didn't deeply feel the line, I knew it was time to stop drawing. In the late 70s, photographer E.G. Schempf said, "It sounds like the work is coming from outside you, outside through you." This comment made me wonder about the possible spiritual source of my drawings. For many years, I searched for answers. Today, I accept, and say "thank you."

DK: *Have you ever produced as big a quantity of drawings in such a short a period of time as you did in the 1970s?*

RB: I produced so many drawings in the '70s, '80s and '90s that it's hard to say there were more in one period or another.

DK: *The circle or a variation of the circle form has always been present in your work. What about that shape appeals to you?*

RB: It is so satisfying — calm and joyous.

DK: *You said that you don't view yourself as a political artist, and yet you seem to be profoundly moved by world events and politics.*

RB: I am very affected by world events. My concerns for the world must play a part in my work even when it appears to be joyous. Of course, on several occasions I have created works which are obviously political statements. I think one of my most powerful sculptures is Inner Torment, my agonized response to witnessing the homeless at Grand Central Station in New York (fig. 224).

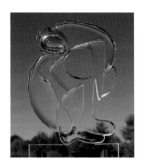

fig 224
Inner Torment *1989,*
acrylic sheet, 31" x 22" x 3"

fig 225
Inner Torment *1988,*
conté on paper, 30" x 22"

DK: *If you get up in the morning and hear something disturbing on the news does it translate into your workday? Or, are you able to set it aside and just create independently of that?*

RB: I find it hard to set anything aside. Therefore, I try not to listen to the news, read the paper or talk on the phone before I create.

DK: *Do you consider yourself part of the feminist art movement?*

RB: Equality for women is very important to me. However, at first the movement seemed so anti-male that it was hard for me to feel a part of it.

DK: *But you had a career at a time when it was very non-traditional to be doing what you did.*

RB: Creating art was what I wanted to do, what I knew would make me happy. It never occurred to me I was taking a feminist position.

DK: *Your drawings seem so completely spontaneous. Is there a spark or synergy between the drawings and your life?*

RB: I'm told that my work reflects my optimism. I am very open and spontaneous.

DK: *If somebody came to you and wanted to commission you to make a sculpture, would you go back to existing drawings or do you sit down and try to draw something new?*

RB: I always go back to existing works that were made for the pure love of drawing. I have great faith in them.

DK: *What do you want to communicate in your more recent work?*

RB: When I create, I'm not thinking of communicating — just expressing myself — I love the comment that I frequently hear: "Your work makes me feel so good."

159

DK: *Is the release you get from the creative process an integral part of who you are?*

RB: Creating makes me feel fully alive!

DK: *In your current work that's related to music, is it a response to the music or an interpretive extension of it?*

RB: Music has been a part of my experience from very early in my career. For many years, I listened to music while working simply because I enjoyed listening. Then, realizing how much the music was influencing my lines, I turned it off — allowing the lines to come from deep within me. This experience intensified when my eyes began closing as I worked.

Now, when I create with music it is definitely a response. Sometimes when I'm drawing at concerts, I feel I'm performing on paper just as the musicians are performing with their instruments. When I'm drawing or painting to music in the studio, I do not touch the canvas — add any paint — without the music guiding me. In recent years, I've discovered I can turn off the music and paint to my own 'inner music.'

DK: *Do you still draw and paint with two hands simultaneously?*

RB: Yes. Most of the time.

DK: *In your studio there are so many found objects from nature: a twig, a shell, leaves, a rock — most seem to reference your work. The rock, for instance, is a perfect oval, which reminded me of your oval drawings. Is there a direct relationship between, say, the oval of the rock and the ovals you have drawn?*

RB: Your question reminds me of the time I went for a walk and picked up a few small branches, hung them on the wall in my studio and was stunned to see that each resembled line drawings hanging near by. The rock's relationship to my ovals is also coincidental. I think of nature as the greatest art.

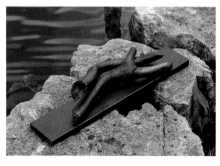

fig 226
Embrace
1984, bronze,
(cast from sticks),
13" x 17" x 4"

DK: *Your recent paintings and sculptures seem to be very physical, more aggressive and bolder, as though a man has done the work. Any idea why that is?*

RB: I know they are very physical, but I never thought of their looking like a man might have done them. That's interesting! My studio, built in 1989, gave me an incredible sense of freedom; I believe this brought new strength to my work.

Also, I've become more confident through the years. The work is very energetic and coming from a deeper level within me (see Chi Paintings, figs. 99-108).

DK: *Why did you abandon realism in the 1960s for abstraction?*

fig 227
Sunlight on the Water
1962, acrylic on
canvas, 30" x 40"

RB: During the early 60s, in order to feel honest, I insisted that my inspiration be taken from reality — even if the painting ended up looking quite abstract, such as Sunlight on the Water (fig. 227). It was only after working with pure shapes while making acrylic sculpture that I would allow myself to make paintings that were not related to real life.

DK: *Why do you think the painting* Sea Gulls and Ocean I *is one of your most important (1966, fig. 220)?*

RB: This was the first time I painted with such freedom. Also, it was the first time I painted nature inside rather than on site.

DK: *Why do you like to paint large?*

RB: I like to move — to reach out in large gestures as far as I can.

DK: *Do you paint the same way you draw, that is, very quickly and spontaneously? Or do you spend weeks working on the same painting?*

RB: My paintings are usually created very fast. Sometimes I wish they took longer.

DK: *The use of color comes and goes in your work. Is there a reason for that? Is the attraction to black the simplicity?*

RB: Probably so. I like to eliminate all that is superfluous and get to the essence. For years I painted only with black. One bold gesture seemed to say everything.

DK: *I know you've gone back from time to time and added color to works that were originally created in black. Was that just spontaneous gesture?*

RB: In 1980, when I first added color with pastels to my black line drawings, I really forced myself to do it, remembering how much I loved working in color. When I added color to my 1996 black line paintings, which I had thought were finished, I worried for a long period of time before touching them. Today, when I add color to my black lines, I often think of it as 'having a dialogue' with my original brush strokes.

DK: *Do you always start with the black lines and then add color or do you ever put the color down first and then add black lines? Or not add black at all?*

RB: I've experimented with all of these ideas. In 1997, I began loading the paint brush with several colors, making the resulting color as much a surprise as my brush strokes.

DK: *Have you ever desired to paint sculpture the way you paint on canvas?*

RB: Sure. In the early 1960s I painted my shaped, suspended canvas sculptures with abstract-expressionist brush strokes while they moved in space. That was a pretty wild experience. And then in the 1990s, I had fun attacking three 5-foot metal sculptures with spray paint.

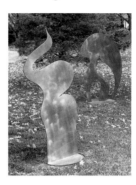

fig. 228
Precocious
1993, painted steel, 65" x 31" x 3/8"
Treasuring (background)
1993, painted steel, 60" x 33" x 3/8"

DK: *Do you consider yourself a painter who creates sculpture, a sculptor who creates paintings or do you make that distinction?*

RB: I was a painter before I ever started creating sculpture. So usually I think of myself as a painter who makes sculpture.

DK: *Do you see a difference between designing sculptures for your own enjoyment as opposed to commissions for a shopping center or a building?*

RB: Only in size. Strangely enough, my drawings seem to translate into any size sculpture.

DK: *What impact has religion had on your art?*

RB: It would be easier for me to say what impact my art has had on my religion, because through creating, I have discovered spirituality.

DK: *In the 20 years I've known you, you are always searching, trying new materials and methods. Are you looking for an ideal expression or meaning?*

RB: No. I'm just always ready to grow, to follow my deepest inspirations, and, above all, to enjoy.

Love from my parents, Dorothy and Herman Copaken, my husband, Irwin Blitt, and our daughter and granddaughter, Chela and Dorianna Blitt, has nourished the spirit that allows me to create. How grateful I am to each of them for this and so much more.

Thanks to my sister and brother-in-law, Shirley and Lewis White, my brother and sister-in-law, Paul and Bunni Copaken, and all my family and friends who are always there for me.

A special thanks to David Knaus for his Interview and wisdom that has helped guide my career; to Sean Kelly for insisting there be a book — "a definitive history of the work of Rita Blitt" — and to the many others who made valuable contributions to this book: Betty Barker Bashaw, Jan Beran, Marj Britt, Nancy Bundt, SuEllen Fried, Barbara Glanz, Judy Glickman, Dorothy Glover, Hannah, Yehuda and Benjamin Hanani, John and Sharon Hoffman, Colette Inez, Peggy Krigel, Tom LoCicero, Robert McDonald, Joyce Miller, Bezalel Narkiss, David Parsons, Robert Peltzman, Shulamit Reinharz, Sylvia Rooth, Sidney Shapiro, Beth Smith, Donna Stein, Sally Sutherland, Patricia Webb, Linda White and Michael Zagalik.

For valuable office assistance, I thank Mirah Rostov, Kay Edwards and the staff of Copaken, White and Blitt.

My thanks to architect Chris Ramos who, along with Irwin, first encouraged me to create sculpture, and to all who have helped me in this endeavor, particularly Uri Seiden, structural engineer and Dave Roth, fabricator in steel and wood; Ted Wilson, fabricator in acrylic; Phil Moore and the staff at Ammon Painting Company; Mussi Art Works Foundry, Inc., fabricators in bronze; and John Dobson at Western Blueprint.

For this very creative book design, I thank Ann Willoughby, Deb Friday, Megan Semrick and the staff at Willoughby Design Group. My thanks, also, to publisher, distributor Theresa Luisotti and co-publisher Brandeis University.

And I thank you, dear reader, for sharing my journey.

figs 229-231
Untitled
1972, conté crayon on paper,
24" x 18"

SOLO EXHIBITIONS

2000 Brandeis University, Waltham, MA, "Rita Blitt: The Passionate Gesture," Nov. 19-Feb. 15, 2000

1998 City Center, New York, NY

1996 Muchnik Gallery, Atchison, KS, Aug. 3-31

1997 Marine's Memorial Theater, San Francisco, CA

1995 Central Exchange, Kansas City, MO, Nov. 20-Jan. 5, 1996
Holt Russell Gallery, Baker University, Baldwin, KS, Sept. 26-Oct. 22
I Space Gallery, sponsored by the University of Illinois, Chicago, IL, March 17-April 15

1994 La Quinta Sculpture Park, La Quinta, CA, Jan. 29-Feb. 28
The Kennedy Museum of Art, Ohio University, Athens, OH, "Rita Blitt in Retrospect," Oct. 7-Nov. 6
Krannert Center for the Performing Arts, University of Illinois, Urbana-Champaign, IL, March 16-27
Krasl Art Center, St. Joseph, MI, "Rough Seas," Oct. 13-Nov. 10

1992 Foothills Art Center, Golden, CO, Sept. 20-Oct. 25
Mackey Gallery, Denver, CO, July 26-Sept. 15
Packers Bank and Trust, Omaha, NE, March
The Aspen Institute, Aspen, CO, "Rita Blitt: Outdoor Sculpture and Drawings," June 14-Aug. 31
Jewish Community Center, Overland Park, KS, "Hallelujah," (with Yehuda Hanani concert), May 2-June 5

1991 Central Exchange, Kansas City, MO
Albrecht-Kemper Museum of Art, St. Joseph, MO, "Reaching Out from Within: The Art of Rita Blitt," July 17-Aug. 30
National Museum Art Gallery, Singapore, "Reaching Out From Within: An Exhibition of Drawings and Sculpture by Rita Blitt," April 16-28

1990 Goldman-Kraft Gallery, Chicago, IL, Nov. 2-29
Mark Twain Gallery, Mark Twain Bank, Kansas City, MO, Jan. 24-March 17

1989 Beit Shmuel Centre, Jerusalem, Israel, February
The Goldman Gallery, Haifa, Israel, February
Mark Twain Gallery, Mark Twain Bank, Ladue, MO, Oct. 18-Nov. 30

1987 Joy Horwich Gallery, Chicago, IL, June 12-July 20
Leedy-Voulkos Gallery, Kansas City, MO, Jan. 9-Feb. 7

1985 Central Exchange, Kansas City, MO, September

1984 Jewish Community Center Gallery, Omaha, NE, "dancing hands: Visual Arts of Rita Blitt," May13-June 10
Rockhurst College, Kansas City, MO, Feb. 19-26

1979 St. Louis University, St. Louis, MO
Johnson County Community College, Overland Park, KS, Jan. 14-Feb. 4

1978 Tumbling Waters Museum of Flags, Montgomery, AL, May 19-Aug. 23
Gargoyle Gallery, Aspen, CO

1977 Martin Schweig Gallery, St. Louis, MO, March 15-April 1
Harkness Foundation of Dance, New York, NY, Dec. 6-17

1974 Johnson County Community College, Overland Park, KS
Ängerer Gallery, Kansas City, MO

1969 Spectrum Gallery, New York, NY, "Orblitts," March 11-29

1967 Halls on the Country Club Plaza, Kansas City, MO, "Canvas in Space: Rita Blitt," Aug. 25-Sept. 15

1965 Unitarian Gallery, Kansas City, MO

1959 Scott's Frames and Gallery, Kansas City, MO

GROUP EXHIBITIONS

1999 Málaga, Spain, "Americans in Spain," Sept. 8-Oct. 16

1998 The Art Source, Indianapolis, IN, April 6-June 19

1997 Dance Aspen, Aspen, CO, July

1995 Obere Galerie, Berlin, Germany
D.I.N. Deutsches' Institut, Berlin, Germany
National Museum of Women and the Arts, Beijing, China, "Global Focus"

1991 Goldman Kraft Gallery, Chicago, IL, Nov. 2-29

1990 Andrea Ross Gallery, Santa Monica, CA, July 19-Aug. 18

1988 Battle Creek Art Center, Battle Creek, MI
Banaker Gallery, Walnut Creek, CA, "Color & Light: Works in Pastel and Glass," Jan. 8-Feb. 27

1987 Kansas Public Library, Kansas City, KS
Banaker Gallery, Walnut Creek, CA, Nov. 18-Dec. 31

1986 Project America, New York, NY

1984 Nebraska Wesleyan University, Lincoln, NE, Jan. 18-Feb. 2
Joanne Lyons Gallery, Aspen, CO

1983 Streker Gallery, Manhattan, KS
Cooke Gallery, Sunset Hill School, Kansas City, MO, Oct. 7-Nov. 4

1982 Biennial, Joslyn Art Museum, Omaha, NE, April 17-June 13
Art & Design Gallery, New York, NY

1981 Tallgrass Fine Arts Gallery, Overland Park, KS, June
Tallgrass Fine Arts Gallery, Kansas City, MO, June
Governor's Mansion, Topeka, KS

1980 Tall Grass Fine Arts Gallery, Kansas City, MO
Elaine Benson Gallery, Bridgehampton, Long Island, NY

1979 Carrefour Gallery, New York, NY
Putney Gallery, Aspen, CO
Gargoyle Gallery, Aspen, CO, Nov. 25-Jan. 5

1978 Arkansas Art Center, Little Rock, AR, Oct. 13-Nov. 12

1977 Cyvia Gallery, New Haven, CT, Oct. 9-Nov. 5

1976 Conry Gallery, Kansas City, MO

1975	Doug Drake Gallery, Kansas City, MO
	Battle Creek Civic Art Center, Battle Creek, MI
1972	Biennial, Joslyn Art Museum, Omaha, NE
1969	Junior League Exhibit, Macy's, Kansas City, MO
1967	Springfield Art Museum, Springfield, MO
	John and Mable Ringling Museum of Art, Sarasota, FL
1964	Mulvane Art Center, Topeka, KS
1963	Jewish Community Center, Kansas City, MO
1959	Kansas City Museum, Kansas City, MO

SELECTED INSTALLATIONS

2000	Brandeis University, Waltham, MA
	Compass Corporate Centre, Overland Park, KS
1998	Hilton Tokyo Bay, Bay Lounge, Shiba, Japan
1996	Taliaferro Sculpture Garden, Prairie Village, KS
1994	Country Club Plaza, Kansas City, MO
1993	Sherman Oaks Medical Center, Sherman Oaks, CA
	Oak Park Mall, Overland Park, KS
1990	Benjamin Plaza, Kansas City, MO
	Mission Center Mall, Mission, KS
1989	Lewis Rice & Fingersh, Kansas City, MO
	Mission Center Mall, Mission, KS
1988	Jewish Community Campus, Overland Park, KS
	Shalom Plaza, Kansas City, MO
1987	Hillcrest Bank Building, Kansas City, MO
1986	Sculpture and Endowment Alcove, B'nai Jehudah Temple, Kansas City, MO
	Town Pavilion, Kansas City, MO
	The Renaissance II, Overland Park, KS
	Loehmann's Plaza, Davies, FL
1985	Loehmann's Plaza, Lake Grove, NY
	Loehmann's Plaza, Babylon, NY, later moved to a Long Island, NY, public golf course
	Loehmann's Plaza, St. Louis, MO
1984	Embassy Suites Hotel, Overland Park, KS
	The Renaissance I, Overland Park, KS
	Loehmann's Plaza, Miami, FL
1983	Loehmann's Plaza, Orlando, FL
	Indian Springs Shopping Center, Kansas City, KS
	State Line Building, Leawood, KS
1982	Rockaway Office Park, Rockaway, NJ
1980	Bannister Mall, Kansas City, MO
1979	Leavenworth Plaza Shopping Center, Leavenworth, KS
1978	Hickory Point Mall, Forsyth, IL
	Rockaway Townsquare, Rockaway, NJ
1977	Rockaway Townsquare, Rockaway, NJ
1975	Oak Park Mall, Overland Park, KS
	Town East Mall, Wichita, KS

164

1974	City Hall, Kansas City, KS
	Jefferson Square Mall, Joliet, IL
	Golden Ring Mall, Baltimore, MD
1973	Eastland Mall, Bloomington, IL
1971	Indian Springs Shopping Center, Kansas City, KS
1969	Pittsburg Mall, Pittsburg, KS
1967	Leavenworth Plaza Shopping Center, Leavenworth, KS
1966	East Hills Mall, St. Joseph, MO
1965	Briarwood Elementary School, Prairie Village, KS
1963	Johnson County Mental Health Center, Shawnee Mission, KS
1957	Dr. Sidney Pakula, Kansas City, MO

COLLABORATIONS WITH PERFORMING ARTISTS

1996	"The Dance Technology Project 1996," Atlanta Ballet, Georgia Institute of Technology and The Parsons Dance Company, Atlanta, GA
1995	St. Joseph Ballet, University of California at Irvine. New Ear Concert, St. Mary's Church, Kansas City, MO
1994	"Runes" (inspired by Blitt drawings), Buglisi-Forman Dance Company, Lincoln Center, New York, NY
1987	"Dream Against Day," The Parsons Dance Company, Dance Theater Workshop, New York, NY
1986	Yehuda Hanani, cellist, recorded music for C h a i sculpture, B'nai Jehudah Temple, Kansas City, MO
1985	Josh Breakstone, guitarist, composed music for sculpture Festivity, St. Louis, MO
	Biaja Fran Solomon, singer, and Dennis Bernstein, poet, composed words and music for sculpture Kharma, Long Island, NY
	John Ciardi, wrote poem given to KCUR, Kansas City, MO, for reproduction on limited edition Blitt print
1984	Mario Lavista, composed music installed in sculpture, Orblitt: 1984, The Renaissance I, Overland Park, KS
	Dr. Michael Udow, percussion professor, University of Michigan, composed music for dancing hands: Visual Arts of Rita Blitt

MUSEUM COLLECTIONS

Albrecht-Kemper Museum of Art, St. Joseph, MO
John F. Kennedy Library, Boston, MA
Skirball Cultural Center, Los Angeles, CA
Spertus Museum, Chicago, IL
Kansas City Children's Museum, Kansas City, MO
The Kennedy Museum of Art, Ohio University, Athens, OH
National Museum Art Gallery, Singapore
Spencer Museum of Art, University of Kansas, Lawrence, KS

SELECTED COLLECTIONS

American Embassy, Barbados
American Express Headquarters, Salt Lake City, UT
The Aspen Institute, Aspen, CO
AT&T, Kansas City, MO
Baker University, Baldwin, KS
Bill Blass, New York, NY
Bloch School, University of Missouri-Kansas City, Kansas City, MO
Blue Ridge Insurance Corporation, Simsbury, CT
Center for Effective Living, Singapore
Colby-Sawyer College, New London, NH
Georgia Institute of Technology, Atlanta, GA
Haifa Symphony, Haifa, Israel
Harkness Ballet Foundation, New York, NY
Hillcrest Banks, Greater Kansas City Area
Johan Jorgen Holst, Oslo, Norway
I-LAN, Taiwan City Hall, Taiwan R.O.C.
Kansas City Parks and Recreation, Kansas City, MO
Lakemary Center, Paola, KS
Lied Center for Performing Arts, University of Kansas, Lawrence, KS
Rollo May, San Francisco, CA
Dr. Ron McCoy, Indonesia
Menorah Medical Center, Overland Park, KS
Former Ambassador to Great Britain & Mrs. Charles Price II, Kansas City, MO
Josef Rotblat, England
St. Louis University, St. Louis, MO
Major Britt Theorin, Sweden
Trinity Lutheran Hospital, Kansas City, MO
University of Missouri-Kansas City, Kansas City, MO
The Women's Foundation, Kansas City, MO
YMCA, Prairie Village, KS

SELECTED BIBLIOGRAPHY

Who's Who in the World, America, American Women, Midwest. Marquis Publications, 1995-2001.
Kaberline, Brian. *Kansas City Business Journal* (April 14-20, 2000), 2.
Sheldon, Bill. "Artist Generous with Her Talent." *Kansas City Star* (Johnson County Living, March 19, 1997).
Glanz, Barbara. *Care Packages for the Work Place.* New York: McGraw Hill, 1996.
Hokubei Mainichi (San Francisco, January 17, 1996).
Hokubei Mainichi (San Francisco, February 7, 1996).
Westover, Phyllis. "Dancing with their Minds." Collections Column, *Potpourri VII*, 2 (1995).
"Sculptures Abound in La Quinta 'Art Park'." *Los Angeles Times*, D Section, J5 1 (January 2, 1994).
Gerry, Catherine Rips. "Rita Blitt Art Feature." *Palm Springs Life* (February 1994).
Thorson, Alice. "Sculpture Finally Finds Home." *Kansas City Star*, Section D3 (May 2, 1994).
"Blitt Exhibit Spans Three Decades of the Artist's Work." *Athens News* (October 3, 1994).
Paglia, Michael. "Rita Blitt." *ARTnews* (January 1993), 151-152.
Bayer, Barbara. "Norway's Peace Efforts Were an Inspiration to Local Artist." *Kansas City Jewish Chronicle* (October 22, 1993), 21.
Root, Jack. "Flag Among Sculptor's Works." *The Sun* (Johnson County, Kansas, July 21, 1993).
Dear Readers. *Arts Rag* (1993).
"Blitt Dances on Paper." *Aspen Times* (July 25-26, 1992).
Thorson, Alice. "Public Art – Who Decides?" *Kansas City Star*, Section J 1, 4 (August 23, 1992).
Jacobs, Andrea. "Sculptures Bigger Than Life." *Intermountain Jewish News* (August 26, 1992).
Dickinson, Carol. "Show Reveals How a Sculptor is Born." *Golden Transcript* (October 13, 1992).
Thorson, Alice. "New Spirit for Kansas City Landmark." *Kansas City Star* (1992).
"Sculptor Reaches from Within to Express Beauty of Life." *St. Joseph News Press/Gazette* (1991).
Sabapathy, T.K. "Dances of Life." *Straits Times* (Singapore, April 16, 1991).
Knaus, David. "Rita Blitt," in *Rita Blitt: Reaching Out from Within.* Singapore National Museum Gallery, April 11-28, 1991.
Koh, Janet. "Reaching Out for Creativity." *Singapore-American* XXXV, 5 (May 1991).
Mason, Nathan. "Rita Blitt." *Kansas City Star* (1991), 4.
"Black Box/Baby Universe II." *International Economy* (August/September 1990), 48-49.
Levine, Angela. "Shapes in a Line." *Jerusalem Post* (February 2, 1990).

Rita Blitt Sculpture. Kansas City, Missouri, 1989.

Goforth, Alan. "Rita Blitt – Kansas City Artist on a Grand Scale." *Kansas City Monthly* (October 1989), 9.

"Rita Blitt, Sculptor." *Ramos Report* (1989).

Hanani, Hannah. "Georgia O'Keeffe and Other Women Artists." *Kansas Quarterly* XIX, (1987), 61-74.

"Easy Does It." *Kansas City Star* (November 5, 1987).

"Name Dropping: Rita Blitt." *The Independent* (1987).

"Gallery Show Highlights Artist's 'Dancing Hands'." *Kansas City Jewish Chronicle* (1987).

Mason, Nathan. "Rita Blitt." *New Art Examiner* (September 1987).

Zimmerman, Sybil. "Local Artist To Show, Donate Work in Israel." *Kansas City Jewish Chronicle* (December 1, 1987).

Hoffman, Donald. "Rita Blitt." *Kansas City Star* (February 19, 1987).

Laumeier Sculpture Park. St. Louis, Missouri, 1986.

New Letters Magazine, 1984.

"Commission." *International Sculpture* (November/December 1984).

"Area Sculptress Creates Soaring, Joyous Forms." *Kansas City Jewish Chronicle* (December 28, 1984).

Watson-Jones, Virginia. *Contemporary American Women Sculptors.* Phoenix, AZ: Oryx Press, 1984.

Knaus, David. "Kansas City: Fine Art on the Frontier." *Art Gallery Magazine* XIX, 4 (1984).

Blitt, Rita. *Nessie the Sculpture,* 1982.

Opsata, Margaret. "In Many Forms, F.A. [Fine Art] Is Filling Shopping Center Market Place." *Shopping Center World* (1981), 171-176.

Blitt, Rita. "Capturing the Motion of a Flag in Painting and Sculpture." *Flag Bulletin* 305, 71 (CV Report, Flag Research Center, Winchester, Massachusetts, 1980).

"Sculptress Thinks Big." *Kansas City Star* (August 8, 1980).

Durham, Darrell. "Dazzling." *Kansas City Times* (August 7, 1980).

Schumacher, Paula. "Dance, Music, Nature Inspire Artist." *The Sun* (Johnson County, Kansas, 1979).

Chain Store Age (December 1978).

"Rita Blitt." *ARTnews* (February 1978).

Shaffer, Jeanne E. "EXPOBLITT." *Advertiser-Journal* (June 10, 1978).

Barnes, Valerie. "Sculpture: A Listing." *New York Times* (1978).

"Busy Week of Openings." *New Haven Register* (October 16, 1978).

Bostic, Virginia. *The History of the Public Monuments & Sculpture of Morris County,* 1978.

"A Report on the Bicentennial Achievements of Women." *Women Involved.* ARBA, Washington, D.C., 1976.

Laphem, Jim. "Her Art Graces Shopping Centers." *Kansas City Star Magazine* (1975).

"Bringing Art to the People." *New York Times* (1975).

Hovey, Juan V. "An Art Axiom Racks in Suburbia." *Kansas City Star* (October 27, 1964).

"Pictures Must Have Meaning Missouri Artist Explains." *The News* (Kansas City, Missouri, December 2, 1961).

"Friends Heckling Led to Rita Blitt Solo Exhibit Next Week." *Kansas City Jewish Chronicle* (November 11, 1960).

FILM, VIDEO and RADIO

Rita Blitt Painting, Videotaped at Georgia Tech, Atlanta, GA (1996).

Blitt Studio Talk for City of Leawood (1996).

Thomas, Arielle. Radio review on KXTR Broadcasting Corp. (Feb. 17, 1984).

dancing hands: Visual Arts of Rita Blitt, 25 minute, 16mm film and video, (Distribution title: *Creating Drawings and Sculpture with Rita Blitt*) Pentacle Productions (1984).

Blitt, Connie. *Orblitts in Aspen*, 10 minutes, Super 8 film (1978).

Flag 1976: Rita Blitt, 7 minutes, 16 mm film; by Pentacle Productions (1975).

INDEX OF COLLECTORS

All unlisted works are in the collection of the artist.

Cover: Seeking Peace, given to Olara Otunnu for the International Peace Academy, New York, NY

Fig. 1: Inspiration, Albert and Judy Ellis Glickman, Cape Elizabeth, ME

Fig. 10: Lunarblitt XVI, "yellow ball," Oak Park Mall, Overland Park, KS

Fig. 13: Untitled, Roberta Tanenbaum, Philadelphia, PA

Figs. 27, 28: Untitled, collection of Keith and Amy Copaken, Mission Hills, KS

Fig. 35: One, The Renaissance I, Overland Park, KS

Fig. 38: Dancing, James and Ilene Nathan, Beverly Hills, CA

Fig. 39: Dancing, Bannister Mall, Kansas City, MO

Fig. 41: Spirit's Delight, Gordon and Marjorie Peck, Toronto, Canada

Fig. 42: Spirit's Delight, Kansas City Parks and Recreation, Kansas City, MO

Fig. 44: Stablitt 55, Rockaway Townsquare, Rockaway, NJ

Fig. 46: Natural Powers, Menorah Medical Center, Overland Park, KS

Fig. 49: I Do, The Aspen Institute, Aspen, CO

Fig. 50: Liberty, Loehmann's Plaza, Davies, FL

Fig. 55: Together, Bannister Mall, Kansas City, MO

Fig. 57: Inspiration, Laura Greenbaum, Mission Hills, KS

Fig. 58: Inspiration, Hillcrest Bank, Kansas City, MO

Fig. 60: Trio, Bannister Mall, Kansas City, MO

Fig. 63: Green Eyes, Jim Roberts, Fairway, KS

Fig. 65: Untitled, collector unknown

Fig. 67: Untitled, Patricia Webb, Chester, CT

Fig. 68: Untitled, destroyed by water damage

Fig. 70: Unfolding, Irvin Belzer and Sue McCord-Belzer, Prairie Village, KS

Fig. 71: Untitled, George and Floriene Lieberman, Leawood, KS

Fig. 72: Oval, Maestro Barry and Rosalind Jekowsky, Tiburon, CA

Fig. 74: Oval, Chela Blitt, Berkeley, CA

Fig. 75: Oval, Amy Ziegler, St. Louis, MO

Fig. 78: Oval, Lewis and Shirley White, Prairie Village, KS

Fig. 79: Oval, Irvin Belzer and Sue McCord-Belzer, Prairie Village, KS

Fig. 80: Orblitt: 1984, The Renaissance I, Overland Park, KS

Fig. 81: Throne of Serenity, Norman and Elaine Polsky, Leawood, KS

Figs. 92a, 92b: Black Box VI, Aspects of Nature I, Melva Bucksbaum, Aspen, CO

Fig. 96: Separate But Together (Variation of Black Box II), The Aspen Institute, Aspen, CO

Fig. 97: Black Box VIII, Fleeting Passion or True Love?, National Museum Art Gallery, Singapore

Fig. 98: Harmony, Norman and Elaine Polsky, Leawood, KS

Fig. 100: Chi Painting, on loan to The Aspen Institute, Berlin, Germany

Fig. 103: Chi Painting, on loan to The Aspen Institute, Berlin, Germany

Fig. 107: Caught #1, Paul and Bunni Copaken, Mission Hills, KS

Fig. 113: Flight of Fancy, David and Jan Morris, Kansas City, MO

Fig. 114: Silent Energy, Shook, Hardy & Bacon, L.L.P., Kansas City, MO

Fig. 115: Joyous Moment, Jeff and Fionnuala Thinnes, Great Falls, VA

Fig. 119: Mozart, Stanley M. and Jane Bloom, Olathe, KS

Fig. 120: Detail of Bach Suite (A), Andrew and Mary Hunt, Snyder, NY

Fig. 121: Bach Suite (B), David Parsons, New York, NY

Fig. 124: Inner Music I, John and Grace Obetz, Leawood, KS

Figs. 131, 132: Untitled, David and Laura Hall, Philadelphia, PA

Fig. 140: Hope, Chela Blitt, Berkeley, CA

Fig. 143: Leap of Faith, on loan to Michael and Nancy Udow, Dexter, MI

Fig. 149: Mysterious Moment, on loan to Ed and Sandi Fried, Leawood, KS

Fig. 156: Kabibi Choo Choo, on loan to Dorianna Blitt, Berkeley, CA

Fig. 160: Red Barn, Arthur Blitstein, Chicago, IL

Fig. 161: Bermuda, on loan to Stanley and Mirah Rostov, Kansas City, MO

Fig. 165: Aspen Violinist, collection of Joan Mae and Gerald Bayer, Northbrook, IL

Fig. 170: Woman Feeding Sea Gulls, collection of Dorothy Glover, Littleton, CO

Fig. 174: On the Beach, collection of and photo courtesy of the Spencer Museum of Art, bequest of Ruth H. Bohan, Lawrence, KS

Fig. 176: Poppies, Donald and Esther Giffin, Kansas City, MO

Fig. 179: Contrast of Youth and Old Age, Paul and Bunni Copaken, Mission Hills, KS

Fig. 181: Scott and His Cat, Richard and Peggy Krigel, Kansas City, MO

Fig. 183: Animals in Space?, Briarwood School, Prairie Village, KS

Fig. 185: Crescendo, Paul and Bunni Copaken, Mission Hills, KS

Fig. 186: In Memory of John F. Kennedy, John F. Kennedy Library, Boston, MA

Fig. 187: Orblitt I, The Hon. and Mrs. Charles H. Price II, Kansas City, MO

Fig. 191: Ode to Matisse, on loan to Ed and Sandi Fried, Leawood, KS

Fig. 192: Stablitt XXXIII, Oak Park Mall, Overland Park, KS

Fig. 193: Flag: 1976, Oak Park Mall, Overland Park, KS

Fig. 194: Struggle for Survival, Skirball Cultural Center, Los Angeles, CA

Fig. 195: Aquablitt, Rockaway Townsquare, Rockaway, NJ

Fig. 197: Destiny, Doris Dubin, Los Angeles, CA

Fig. 199: Nessie, Rockaway Townsquare, Rockaway, NJ

Fig. 200: Yellow Dot, Jon and Shelly Copaken, Kansas City, MO

Fig. 201: Kindness Poster, Stop Violence Coalition, Kansas City, MO

Fig. 202: Spirit's Delight and Kindness is Contagious. Catch It!, Hilton Tokyo Bay, Bay Lounge, Shiba, Japan

Fig. 203: Reality ?, Mr. and Mrs. Robert Beatty, Oak Brook, IL

Fig. 205: Grace, Mission Center Mall, Mission, KS

Fig. 209: Happy Day Mom, Chris Ramos, Kansas City, MO
Fig. 211: Rhapsody, John and Carlene Reininga, San Francisco, CA
Fig. 212: Seth's Black Box, Seth and Lisa Prostic, Chicago, IL
Fig. 213: Jazz, Andrew and Mary Hunt, Snyder, NY
Fig. 214: St. Joseph Ballet, Saint Joseph Ballet of Santa Ana, CA
Fig. 217: Joie d'Vivre, Ann Hyde, Kansas City, MO
Fig. 218(left): Bountiful Love, Nancy Kingsbury, Statesboro, GA
Fig. 219: Delight, Compass Corporate Centre, Overland Park, KS
Fig. 220: Seagulls and Ocean I, Paul and Jill Van Osdol III,
 Gladstone, MO
Fig. 223: "La Concurrence," published in *New York Times*, 1973
Fig. 228: Precocious, Marcia Rinehart, Leawood, KS
Fig. 228: Treasuring, Lake Mary Center, Paola, KS

PHOTOGRAPHERS

Note: All photographs with known attributions are listed

Nancy Bundt, Norway: page 38
Jan Beran, Czech Republic: figs. 35, 80
Paul Chesley, Aspen, CO: figs. 49, 95, 96, 109
Judy Ellis Glickman, Cape Elizabeth, ME: fig. 1
Aaron Hoffman, Boulder, CO: fig. 170
Stuart Huck, Basalt, CO: cover, figs. 92a, 92b, 94a, 94b, 123, 124,
 135-139, 141-145
Dan Kaplan, Kansas City, MO: fig. 187
Malcolm Lubliner, Oakland, CA: figs. 125-130, 133, 134, 215
James Maidhof, Shawnee Mission, KS: figs. 192, 202
David O. Marlow, Aspen, CO: figs. 140, 146, 148
Carlene Reininga, San Francisco, CA: fig. 211
Nathan Rabin, Toms River, NJ: fig. 194
Rosemary Reeves, Rockaway, NJ: fig. 44
E.G. Schempf, Kansas City, MO: figs. 131, 132, 151, 157, 162-164,
 166-169, 171-173, 175-177, 181, 182, 184, 185, 188, 189, 207, 208,
 216a, 216b, 220, 221, 227
Joe Schopplein, San Francisco, CA: fig. 213
Robert Wedemeyer, Los Angeles, CA: fig. 38
Michael Zagalik, Kansas City, MO: figs. 2-34, 36, 37, 39-43, 45-48,
 51-71, 73-79, 81-91b, 93, 97-108, 110-122, 149, 154-156, 158,
 159, 161, 178-180, 183, 186, 190, 191, 193, 196-198, 200, 201,
 203-206, 209, 210, 212, 217, 218, 222-226, 228-231

RITA BLITT: THE PASSIONATE GESTURE

Designed by Willoughby Design Group, Kansas City, Missouri,
Spring of 2000, with Goudy OldStyle and Zurich fonts.
Printed by Gardner Lithograph, Buena Park, California.
Text and dust jacket of 100 lb. Utopia One balanced white dull text.
End sheets of 80 lb. Confetti purple text.
Deboss die by Olympic Graphics, Lenexa, Kansas.
Bound by Roswell Bookbinding, Phoenix, Arizona in Brillianta Book Cloth.

first edition of 5,000